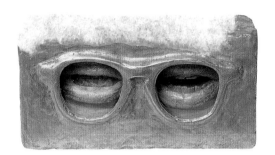

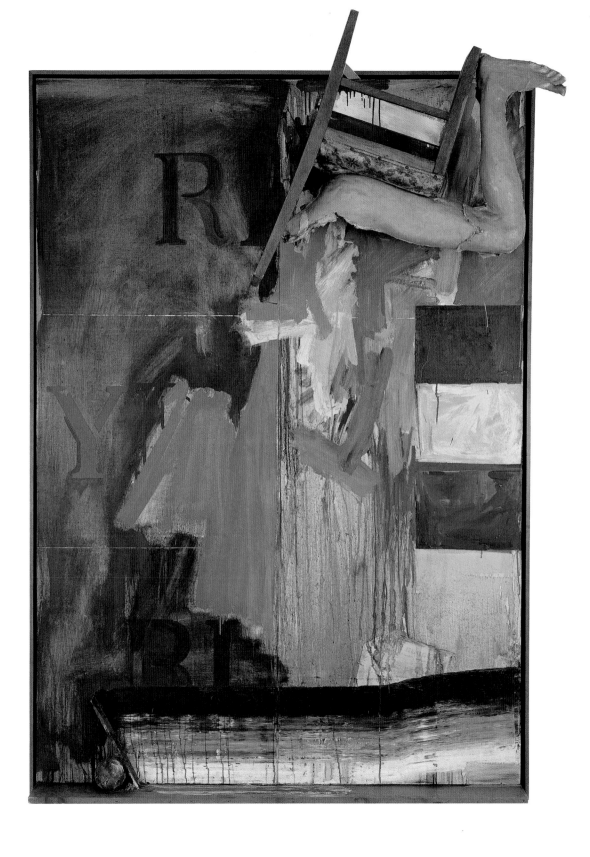

Barbara Hess

JASPER JOHNS

"The Business of the Eye"

TASCHEN

HONG KONG KÖLN LONDON LOS ANGELES MADRID PARIS TOKYO

To stay informed about upcoming TASCHEN titles,
please request our magazine at www.taschen.com/magazine
or write to TASCHEN America, 6671 Sunset Boulevard,
Suite 1508, USA-Los Angeles, CA 90 028,
contact-us@taschen.com, Fax: +1–323–463.4442.
We will be happy to send you a free copy of our magazine
which is filled with information about all of our books.

© 2007 TASCHEN GmbH
Hohenzollernring 53, D–50672 Köln
www.taschen.com
© VG Bild-Kunst, Bonn 2007 for the works of Jasper Johns

Project management: Petra Lamers-Schütze, Cologne
Coordination: Christine Fellhauer, Cologne
Translation from German: John William Gabriel, Worpswede
Production: Ute Wachendorf, Cologne
Layout: Claudia Frey, Cologne
Cover design: Claudia Frey, Cologne

The publisher wishes to thank Jasper Johns
and Sarah Taggart for their generous cooperation.

Printed in Germany
ISBN-13: 978-3-8228-5171-5
ISBN-10: 3-8228-5171-x

Contents

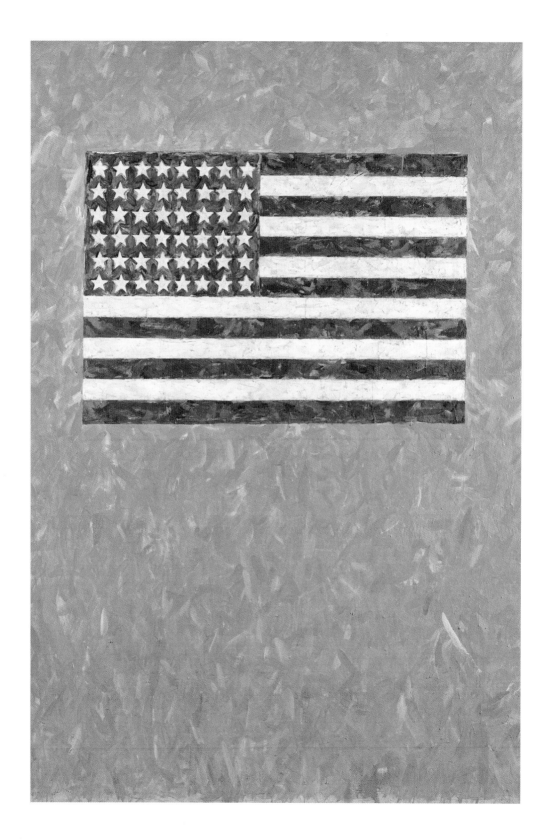

"Is it a flag, or is it a painting?"

"The mature work of Johns begins with the first *Flag,* painted in 1955," stated art historian Alan R. Solomon in 1964 (p. 9). It was not the familiar motif of a flag flapping in the wind, its form continually changing, that Johns depicted, but the flag as a flat, immobile, two-dimensional object. The laconic title, *Flag,* underscored this focus and yet was misleading, because rather than being a real, readymade flag, it was a depiction of one. Recalling René Magritte and his famous image of a pipe with the caption "Ceci n'est pas une pipe," we might contradict Johns's title and declare: This is not a flag.

With *Flag,* Solomon added, the 25-year-old Johns gave "the impression of a finished artist, suddenly sprung from nowhere." His image of the American flag became the motif with which Johns was most closely identified, especially because he took it, like many of his motifs, through numerous variations over the following decades. The identity of the motif with the pictorial field, highly unusual at the time, intrigued early commentators. "To put the matter simply," wrote Solomon, "we saw a flag, an object which offers none of the possibilities of formal manipulation, of the making of decisions about the disposition of shapes on the surface, a predisposition upon which all modern painting has depended since Cubism."

Another early observer, the composer John Cage, suggested a link between *Flag* and a different medium. Cage compared the composition to the structure of a sonnet, which divides "fourteen lines into eight and six." Just as every sonnet is based on this structure, Cage suggested, the structure of *Flag* followed that of the American flag: "Beginning with a flag that has no space around it, that has the same size as the painting, we see that it is not a painting *of* a flag. The roles are reversed: beginning with the flag, a painting was made. Beginning, that is, with structure, the division of the whole into parts corresponding to the parts of a flag, a painting was made which both obscures and clarifies the underlying structure."

This impression of both/and, the ambiguous nature of the image, has continued to fuel the debate on Johns's *Flag* paintings to this day. To contemporary viewers, *Flag* appeared to unite two opposing and seemingly incompatible concepts and approaches: original and reproduction, the gestural painting of Abstract Expressionism and Marcel Duchamp's idea of the ready-made. It was in view of this ambivalent situation that Solomon quoted Johns's rhetorical

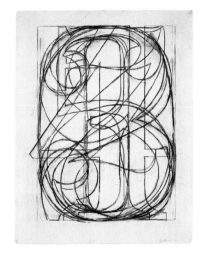

0 through 9, 1960
Charcoal on paper, 73.3 x 58.1 cm
Artist's collection

The point of his numbers paintings, Johns emphasized, was not to make anything useful but to reflect the physical effort of painting the picture and the reaction when it was viewed.

ILLUSTRATION PAGE 6:
Flag on Orange Field, 1957
Encaustic on canvas, 167.6 x 124.5 cm
Cologne, Museum Ludwig, Ludwig Foundation

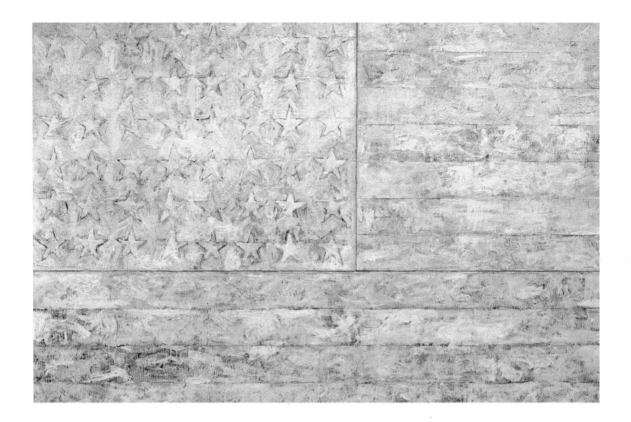

White Flag, 1955
Encaustic and collage on canvas (three panels),
198.9 x 306.7 cm
New York, The Metropolitan Museum of Art

Johns's paintings of motifs such as flags, letters,
and targets play on the ambivalence between
image and object. The use of an alienating
monochrome palette, as in the monumental
White Flag and *Green Target* (p. 10), increase
this ambivalence still further.

"What is the individual's ongoing relation to,
or sense of belonging to, the national culture she
may serve or criticize, but which has also helped
shape her life and thought? This is the question
embodied by Jasper Johns's *Flag*. It has never
been more relevant than now."
ANNE M. WAGNER, 2006

question, "Is it a flag, or is it a painting?" Johns's early subjects—flags, targets,
letters and numerals—were two-dimensional; depicting them amounted to
reproducing them. "Using the design of the American flag took care of a great
deal for me, because I didn't have to design it," Johns commented to Leo Steinberg
in 1963. "So I went on to similar things like the targets—things the mind already
knows. This gave me room to work on other levels." (pp. 10, 14, 15)

One of these "other levels" was doubtless Johns's unusual painting technique,
encaustic, used for the first time in *Flag*. In this technique, oil paint and news-
paper were mixed with molten wax and applied to the canvas. The use of news-
paper in works of art had been common ever since the collages of the Cubists
and Dadaists. Later, Abstract Expressionist artists like Franz Kline and Willem
de Kooning had painted on pages from telephone books or integrated offprint
impressions from newspaper pages in their paintings. The employment of wax,
however, was a new step, which served several purposes for Johns: "I wanted to
show what had gone before in a picture, and what was done after that. But if you
put on a heavy brushstroke in paint, and then add another stroke, the second
stroke smears the first, unless the paint is dry. And paint takes too long to dry.
I didn't know what to do. Then someone suggested wax. It worked very well;
as soon as the wax was cool, I could put on another stroke and it wouldn't alter
the first." The wax, in other words, conserved the character of each individual
brushstroke. This conformed with Johns's desire to focus on "concrete" things.
As art critic Harold Rosenberg, an erstwhile advocate of the Abstract Expressionists,

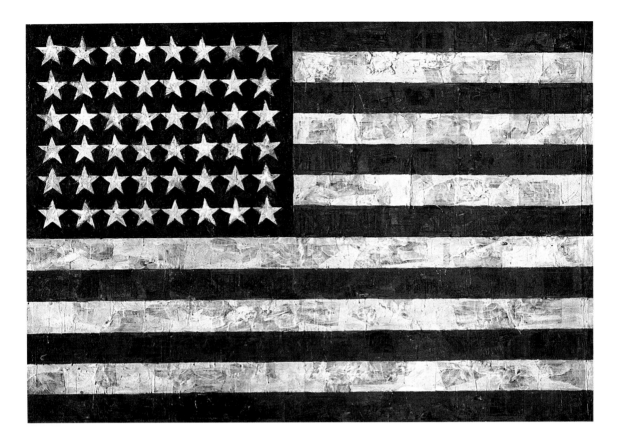

noted in 1964, "For Johns the paint stroke of a Kline or a Guston is as external a 'thing' as the flag or the letter 'Z'…"

Johns's use of encaustic was not only uncommon to the point of becoming his trademark. It enabled him to make visible each separate stroke, and thus the painting process itself, a symbolic embodiment of the multilayered nature of his work. Most of all, encaustic enabled Johns to gain control over the paint drips that were such a key feature of Abstract Expressionist gestural painting. "When I came to New York in the fifties, Abstract Expressionism was rampant … One felt that it was in very good hands and one did not have to be concerned with it," as Johns recalled in an interview with Peter Fuller. Another unique property of encaustic was the strong physical presence of the wax-and-paint layer. Willem de Kooning, a dominant figure on the New York art scene of the day, had said in 1950 that flesh was the reason for the invention of oil painting. This organic quality was perhaps even more strongly conveyed by the shimmering wax surfaces of Johns's paintings. "Encaustic (flesh?)," he noted in a sketchbook in 1965.

On the level of motifs, flags and targets fulfilled a further basic precondition of his work. Not only were they "concrete," but they were "both things which are seen and not looked at, not examined, and they both have clearly defined areas which could be measured and transferred to canvas," as Johns explained to Walter Hopps in 1965. Flags, targets, numerals, letters and maps were "pre-formed, conventional, depersonalized, factual, exterior elements," he told David

Flag, 1954–1955
Encaustic, oil and collage on fabric, mounted on plywood (three panels), 107.3 x 153.8 cm
New York, The Museum of Modern Art. Gift of Philip Johnson in honor of Alfred H. Barr jr.

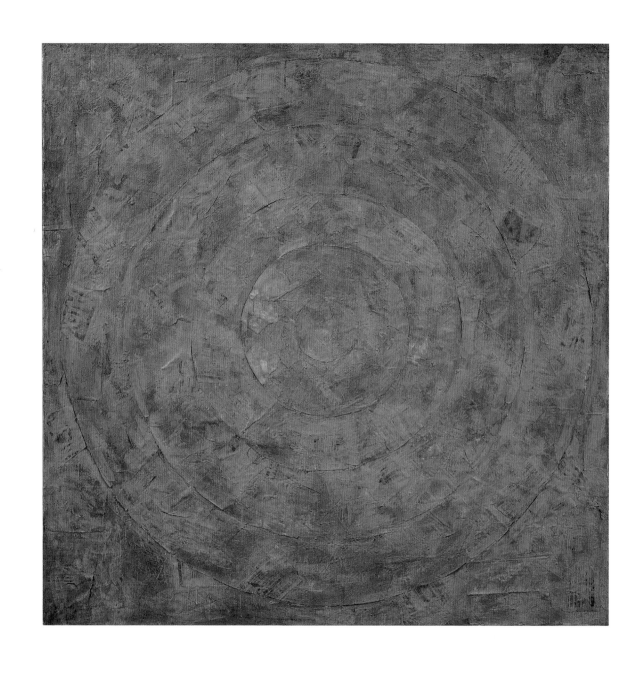

Green Target, 1955
Encaustic on newspaper and cloth
over canvas, 152.4 x 152.4 cm
New York, The Museum of Modern Art.
Richard S. Zeisler Fund

Sylvester that same year, "things which suggest the world rather than suggest the personality. I'm interested in things which suggest things which are, rather than in judgements." His paintings should be looked at "the same way you look at a radiator," Johns explained in *Time Magazine* in 1959.

Of course the famous national symbol of the Stars and Stripes was anything but a neutral object like a radiator. By the mid 1950's, the United States had advanced to become a world power on the political and economic stage. In December 1942, Congress had established detailed legal stipulations on the public use of the flag, the way it was to be raised, saluted, and handled. In 1954, Flag Day, the annual commemoration of the introduction of the American national flag on June 14, 1777, was celebrated with great pomp and circumstance, as reflected in the widespread media reports detailed by art historian Fred Orton. In the political climate of the Cold War, patriotic tendencies proliferated. By 1955, the country could look back on the McCarthy Era, years of persecution of real and alleged communists and their "un-American activities" in wide sectors of society. The cease-fire of the Korean War, in which Johns himself had been involved as a soldier, was not signed until 1953.

So it was hardly surprising that Leo Steinberg, who published the first monograph on Johns in 1963, saw a political—if not necessarily national—symbolism in the composition of *Flag*. As Steinberg pointed out, Johns's red and white stripes evinced no figure-ground relationship of the kind found in conventional stripe patterns: "All the members exist in a state of democratic equality, every part of the image tending toward the picture plane, as water tends to the sea level."

Over the years, Johns's *Flags* were repeatedly drawn into the political context, as when the artist's dealer, Leo Castelli, presented a bronze *Flag,* 1960, to President John F. Kennedy on the occasion of Flag Day in 1964. Johns disapproved of this sort of instrumentalization of his art. As he reported to Peter Fuller in 1978, he had told John Cage how much this incident angered him. Cage, however, calmed his friend down, suggesting that he simply take it as a pun on his art. When Fuller remarked that Johns could not avoid the meaning of the symbols he employed, the artist replied that anything could be used, abused, or become invisible. Apparently this attitude gave Johns the liberty to vary the flag motif even in a concrete political connection. In 1986, for the design of a "Medal of Liberty," he employed a bronze cast of a pantographically reduced version of his sculpted metal *Flag* of 1960. This medal was presented by President Ronald Reagan to twelve naturalized American citizens on July 3, 1986.

Initially Johns hoped that the anonymity of his subject matter would prevent his works from being read as expressions of individuality. The audiences of Abstract Expressionism tended to expect the very opposite—an art of soul-searching and self-revelation. Johns obviously had no intention of meeting this expectation. "I have attempted to develop my thinking in such a way that the work I've done is not me—not to confuse my feelings with what I produced. I didn't want my work to be an exposure of my feelings," he told Vivien Raynor in 1973. The idea of depicting the American flag was not prompted by any actual visual observation. It came to Johns in a dream, and he put it into practice the very next day—a way of image-finding that recalls Surrealism. "People dream of so many things," Peter Fuller suggested. "Why did you decide to make the flag?" "I don't know," Johns replied. "I have not dreamed of any other paintings. I must be grateful for such a dream! [Laughs.] The unconscious thought was accepted by consciousness gracefully."

"You can only investigate something about which you have previously dreamed."
GASTON BACHELARD, 1949

White Numbers, 1957
Encaustic on canvas, 86.5 x 71.3 cm
New York, The Museum of Modern Art.
Elizabeth Bliss Parkinson Fund

Jasper Johns was born in 1930, in Augusta, Georgia. After his parents divorced, in 1932 or 1933, he initially grew up with his paternal grandfather, who lived with his second wife, Montez B. Johns, in Allendale, South Carolina. Johns once described his childhood milieu as "entirely Southern, small-town, unsophisticated, a middle class background in the Depression years of the thirties." In the early 1960's, he recalled in an interview that he began to draw when he was three, and never stopped. He had wanted to become an artist ever since he was five years old. His childhood, as he told Peter Fuller, "wasn't especially cheerful." From summer 1940 to the end of school in fall 1946, Johns lived with his aunt, Gladys Johns Shealy, who taught at the local school and whose class he attended for six years. "My Aunt Gladys once, when she read a thing in a magazine, wrote me a letter, saying that she was so proud of me, because she had worked so hard to instill some respect for the American flag in her students, and she was glad the mark had been left on me," Johns reported to the filmmaker Emile de Antonio in 1972. When another interviewer, Paul Taylor, suggested in 1990 that the flag might be a stand-in for him, Johns demurred: "I don't think so. The only thing I can think of is that in Savannah, Georgia, in a park, there is a statue of Sergeant William Jasper. Once I was walking through this park with my father [William Jasper Johns], and he said that we were named from him. Whether this is in fact true or not, I don't know. Sergeant Jasper lost his life raising the American flag over a fort. But according to this story, the flag could just as well be a stand-in for my father as for me." William Jasper was a hero of the American War of Independence. A sergeant in the 2nd South Carolina Regiment, he went down in history when, in 1776 at Fort Moultrie, he re-raised the regimental flag that had been shot down in a British attack. As Johns related, Jasper fell in 1779 in Savannah, during a further attempt to hoist his regiment's flag on the British front lines. In his memory, several American cities and counties adopted his name.

Gray Alphabets, 1956
Beeswax and oil on newsprint and
paper on canvas, 168 x 123.8 cm
Houston, TX, The Menil Collection

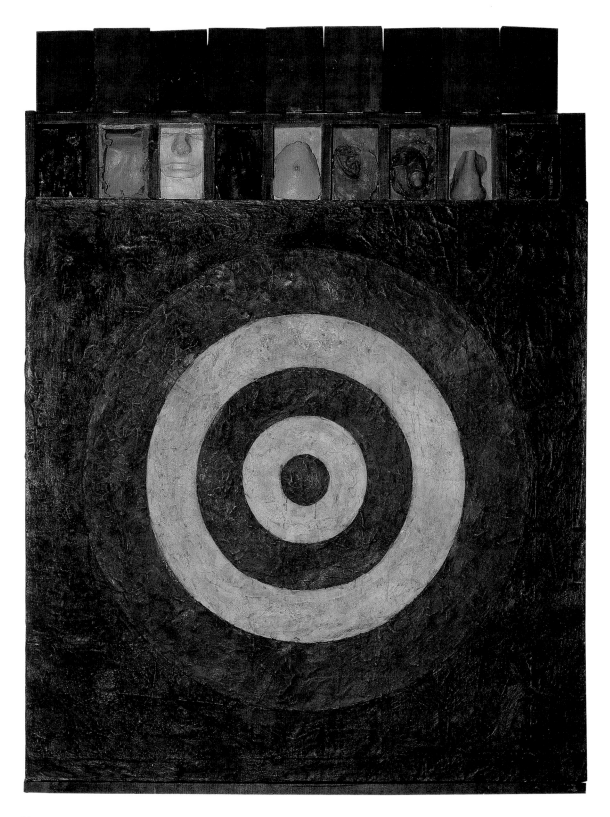

"A Vital Neo-Dadaist Spirit"

The "nowhere" out of which Alan Solomon saw Johns suddenly emerge with his first *Flag* painting in 1955, was in fact a carefully staged debut. In 1953 and 1954, he had begun to systematically destroy his earlier works. Later he would even buy early works back for the same purpose. Against the background of this tabula rasa, *Flag* (p. 9) could appear all the more programmatic and ambiguous. Many years later, in an interview published in *Newsweek*, Johns explained his iconoclasm as follows: "It was an attempt to destroy some ideas about myself … It gets to sound very religious, which I don't like, but it's true." In fact Johns would come to be known for his "skill and daring at rebuilding his past," as the author Michael Crichton put it. Speaking with Paul Clements in 1990, Johns emphasized his conscious effort not to do anything that could be confused with the work of other artists, and his desire to create his own identity. Later, he added, it was no longer so important whether he was himself rather than somebody else. The fact that he succeeded in creating his own personal identity with motifs as anonymous as flags, targets, numerals and letters, is one of the paradoxes that marks Johns's art.

Thanks to his self-censorship, only a handful of works that were no longer in his possession at the time remain from Johns's production prior to *Flag*. One of these is *Untitled*, 1954, a small-format, monochrome green painting with a grid structure of collaged paper arcs (p. 16). Johns had found the paper in Marboro Books, an art-book store where he worked at the time. "I used to fold these sheets and then tear them," he recalled, "so that when they were opened the tears made a symmetrical design. This collage was a collection of torn sheets. The idea was to make something symmetrical that didn't appear to be symmetrical." Two still-lifes have also survived—highly condensed graphite drawings of dried oranges on oil-soaked paper (p. 20). These likewise show an effect of mirroring and near-symmetry, a factor that Johns would subsequently emphasize in numerous later works (p. 35). In another early work, *Construction with Toy Piano* (p. 18), he incorporated the numbered keys of a toy piano, which actually produce sounds. As Johns explained, he was interested in the idea of a painting "that did more than one thing, that had another aspect. That was the reason for the sound."

Untitled, 1954, is likewise a hybrid construction, consisting of a wooden box with two different-sized compartments containing reworked visiting cards and a plaster cast of the face of Rachel Rosenthal, a student of the choreographer

Target, Universal Limited Art Editions, 1960
Lithograph, 57.5 x 44.7 cm
New York, The Museum of Modern Art. Gift of
Mr. und Mrs. Armand P. Bartos

Johns's work is marked by an ongoing interest in repeating his motifs in various media. The aim is a dual analysis: "to observe the play between the two: the image and the medium."

ILLUSTRATION PAGE 14:
Target with Plaster Casts, 1955
Encaustic and collage on canvas with objects,
129.5 x 111.8 x 8.8 cm
Collection David Geffen

15

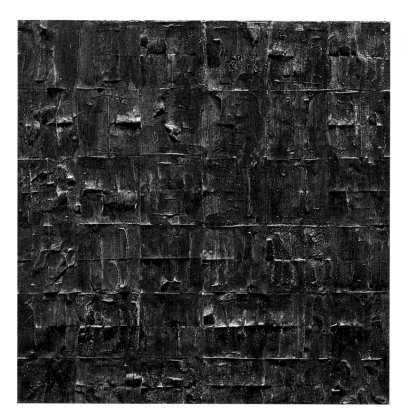

Untitled, 1954
Oil on paper, mounted on fabric, 22.9 x 22.9 cm
Houston, TX, The Menil Collection

Merce Cunningham (p. 21). The object *Star* (p. 17), is a white triangular box with
the lid reversed to produce a Star of David shape. According to Crichton, this
was Johns's first commissioned work: "He had done a painting in the shape of a
cross, and Rachel Rosenthal said she would buy it if it were a Jewish star. Johns
made one; she bought it."

All of Johns's early works are characterized by a reliance on existing symbolic
forms and mundane materials, combined into collages or assemblages. They
were done at a time when the New York art scene was experiencing a fundamen-
tal transition. The dominant tendencies in painting of the 1940's and early 1950's,
collectively labeled Abstract Expressionism, had entered a crisis—described by
influential minds as a threatening stagnation and academic torpor. In 1952,
Harold Rosenberg said that the work of the American Action Painters—once
viewed as the liberated expression of individuals alienated from society—had
become a commodity with a successful brand name, an "apocalyptic wallpaper."
Another fundamental change seemed to be the increasing retreat of many artists
from the social and political debate that had marked the 1930's. Their social role,
largely defined by the 1940's as that of outsiders who could hardly live from their
art and could hope for posthumous fame at best, now appeared to be increas-
ingly shifting to that of socially recognized and integrated figures. The critic
Dore Ashton, a contemporary of the protagonists of Abstract Expressionism,
noted that in the early 1950's a few artists "were escaping from the egalitarian
condition of poverty."

By the middle of the 1950's, new aesthetic impulses were coming less from
the field of visual art than from an exchange among representatives of diverse

"And I think now that our main conception
of an object is that it will hold something."
JASPER JOHNS, 1965

Star, 1954
Oil, beeswax and house paint on newspaper,
canvas and wood with tinted glass, nails and
fabric tape, 57.2 x 49.5 x 4.8 cm
Houston, TX, The Menil Collection

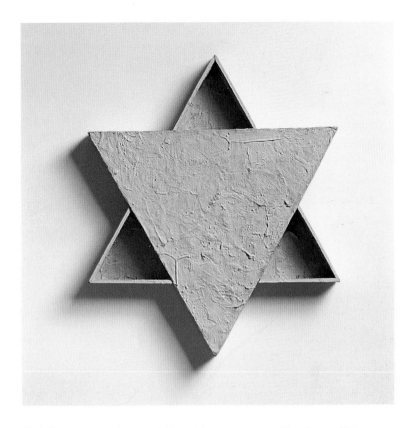

disciplines. Among the most influential were composers like Cage and Morton Feldman, whose New York performances were attended by many visual artists and writers. Cage's experimental method, influenced by Buddhist and Tantric philosophy, rested on the inclusion of chance and paradox in the composing and performing of his works. His renowned "Lecture on Nothing," held in 1954 at the Eighth-Street Club, a New York artists' watering hole, ended with the statement that when he wasn't working, he sometimes thought he knew something about his method, but when he was working, it became obvious that he knew nothing. Many of Johns's sketchbook notes and interview statements sound like echoes of Cage's thinking and writing, as when he explained in 1959: "Sometimes I see it and then I paint it. Other times I paint it and then I see it. Both are impure situations, and I prefer neither." And just as Cage's "Lecture on Nothing," composed like a piece of music or a poem, conveyed the impression that it had no "content" that could be grasped independently of its form, the unity of content and form in Johns's paintings was indissoluble. Asked about the influence of Cage's thinking on his art in a 1990 interview by Ruth Fine and Nan Rosenthal, Johns replied, "His music was new to me, and his interest in the use of chance and sounds from the environment helped open my ears, and my eyes too, to new forms and possibilities. … This was in the mid-1950's, when Cage, Merce Cunningham, Bob Rauschenberg, and I met frequently. … I was the youngest of the group, the most susceptible to influence, and the one, I suppose, to benefit most from the association."

Johns had studied art at the University of South Carolina in 1947–48. At the end of that year he began to continue his studies in New York, yet was forced

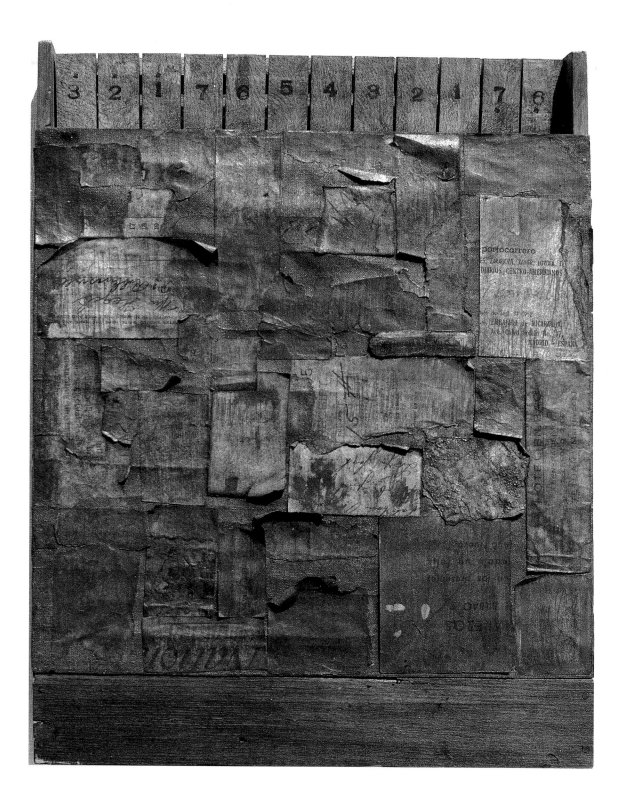

to interrupt them due to financial difficulties. In 1951 he was inducted into the Army, where he initiated an exhibition program for the troops, and was stationed in Japan for a few months during the Korean War. After his discharge from the Army in 1953, Johns registered at Hunter College in New York on the G. I. Bill, a stipend for veterans. On the way home after his very first day at college, he suffered a breakdown. He was rescued and stayed in bed for a week, and that was the end of his "career in higher education," as Johns recalled this biographical turning point in an interview for *The New York Times* in 1977.

A few months later, Johns met Robert Rauschenberg. Later he would describe Rauschenberg, who was five years his senior, as the first person he knew who was "a real artist." Also dating to about this time was Johns's insight into the difference between "going to be" and "being," and his determination to avoid perpetually "going to be" an artist. Over the following years, Johns and Rauschenberg developed a close living and working relationship. At the time, Rauschenberg was making a living by decorating display windows, and Johns assisted him. In 1955 they named their firm Matson Jones—Custom Display, out of shame, as Rauschenberg ironically wrote, because their ideas were "beginning to meet the insipid needs of the business."

On the artistic level, a lively exchange of ideas began. He and Johns were their own first serious critics, Rauschenberg recalled, and literally "traded ideas." Johns, in turn, admitted to having once painted two Rauschenbergs, because he believed he knew his friend's work well enough to do it himself. In the end, however, he passed the paintings on to Rauschenberg, who finished them and sold them under his own name. Accordingly, there are many parallels between Johns' and Rauschenberg's early works, including the use of boxes and crates— an aspect Johns observed in the Surrealist-influenced assemblages of Joseph Cornell, which he saw in New York in 1954. Rauschenberg, too, began in the early 1950's to integrate existing materials such as printed matter into his collages, and experimented with monochrome painting. The flag motif, too, might have been something Johns encountered in his personal environment. The artist Sari Dienes, whom he met in 1953, had employed it in 1950 as an element of a collage entitled *Tomb*.

In a certain sense, Rauschenberg was the first to exhibit a Johns *Flag*—embedded in his own *Short Circuit*, shown that year in the "Fourth Annual Exhibition of Painting and Sculpture" at the Stable Gallery, New York (p. 19). The gallery's annual group shows were based on the rule that artists who had participated in previous years were permitted to suggest others for the next exhibition. When his suggestions were not accepted, Rauschenberg protested by offering to integrate works by Ray Johnson, Stan Vanderbeek, Susan Weil and Jasper Johns in his own piece. In the end, only pictures by Weil, Rauschenberg's former wife, and Johns were employed. Moreover, *Short Circuit* included a program of an early Cage concert and a signed photo of the actress and singer Judy Garland, which some art historians, such as Thomas Crow, have interpreted as an allusion to the culture of the homosexual community, among whom Garland had numerous fans at the time. The Weil and Johns works were concealed behind closed wooden doors with a sign saying Do Not Open. Rauschenberg's assemblage was bought by the dealer Leo Castelli. In 1965, it was discovered that Johns's *Flag* had apparently been stolen; Rauschenberg replaced it with a facsimile by Elaine Sturtevant. The fact that Rauschenberg and Johns were no longer together at this point in time and had no contact with each other for many years, may be one reason why the pilfered painting was not replaced by another Johns *Flag*—which

ILLUSTRATION PAGE 18:
Construction with Toy Piano, 1954
Graphite and collage with toy piano,
29.4 x 23.2 x 5.6 cm
Basel, Öffentliche Kunstsammlung Basel,
Kunstmuseum

In early 1954, Johns got to know the composers John Cage and Morton Feldman, and the choreographer Merce Cunningham. Robert Rauschenberg was designing sets and costumes for Cage and Cunningham productions at the time. In this context, Johns expanded his art by an acoustic and performative function.

Robert Rauschenberg
Short Circuit, 1955
Mixed media, 126.4 x 118 x 12.7 cm
Collection Robert Rauschenberg

Untitled, 1954
Graphite pencil on oil (?) stained paper,
22.2 x 16.7 cm
Collection Robert Rauschenberg

Johns's early graphite drawing is viewed as a still
life with two dessicated oranges. It anticipated
later paintings in terms of both material and
motif, such as the constricted balls in *Painting
with Two Balls* (p. 31) and the impressions of
Johns's oil-covered face in *Study for Skin* (1962)
which served as a model for *Skin with O'Hara
Poem* (p. 49 top).

ILLUSTRATION PAGE 21:
Untitled, 1954
Construction of painted wood, painted plaster
cast, photomechanical reproductions on canvas,
glass and nails, 66.7 x 22.5 x 11.1 cm
Washington, DC, Hirshhorn Museum and
Sculpture Garden, Smithsonian Institution.
Regents Collection Acquisitions Program, with
Matching Funds from the Thomas M. Evans,
Jerome L. Greene, Joseph H. Hirshhorn, and
Sydney and Frances Lewis Purchase Fund, 1987

would have seemed a reasonable option in view of the artist's practice of repeating motifs.

In 1964 Sturtevant had begun making replicas of works by other artists as a way of paying homage to them. Her provocative production began with the silkscreens used to print Andy Warhol's *Flowers*, 1964, which the artist made available to her. Rauschenberg's use of Sturtevant's *Johns Flag* was a further example of the early recognition accorded to her subversive practice.

Walter Hopps spoke in the 1990's of Rauschenberg's "art of fusion," of which his collective work *Short Circuit* was a prime example. It stood for a new, straightforward, and generous way of dealing with reciprocal influences. At that period, heterosexual artist couples seemed to have a much harder time in this regard, their mutual influence generally being viewed as one-sided, and one of the pair enjoying more success than the other. The works and careers of couples prominent on the New York scene, such as Jackson Pollock and Lee Krasner or Elaine and Willem de Kooning, were marked by rivalry and a staking out of claims. By contrast, the relationship between Johns and Rauschenberg, and their friendship with Cage and Cunningham, involved reciprocal exchange and occasional collaboration on common projects. "Each seemed to pick up where the other left off," Cage recalled. "The four-way exchanges were quite marvelous. It was the *climate* of being together that would suggest work to be done for each of us."

Apart from an "exhibition" of *White Flag* (p. 8) as part of a window display at Bonwit Teller in 1956, the showing of *Green Target* (p. 10) at New York's Jewish Museum was a key step towards a greater public awareness of Johns's art. His artist colleague Allan Kaprow had advocated Johns's inclusion in "Artists of the New York School: Second Generation," which opened in March 1957. There Leo Castelli, who had just established his gallery, saw a Johns piece for the first time. The following evening, Castelli, his wife Ileana, and a gallery assistant paid a visit to Rauschenberg's studio. Leo Castelli remembered Johns's name; he had a loft in the same building, and Castelli asked to meet him. His guests were evidently immediately taken by Johns's work. Ileana Castelli acquired a painting, and a gallery show was agreed upon—the beginning of a decades-long successful cooperation.

To begin with, Castelli showed *Flag* (p. 9) in May 1957 in the group exhibition "New Work: Bluhm, Budd, Dzubas, Johns, Leslie, Louis, Marisol, Ortman, Rauschenberg, Savelli," where it caught the attention of the critic Robert Rosenblum. In his review, after rhetorically asking whether the piece was blasphemous or respectful, simple-minded or recondite, Rosenberg concluded that it reflected the workings of "a vital Neo-Dadaist spirit." In the ensuing public debate over the following months, terms like "Dadaism" and "anti-art" were frequently used in connection with Johns, Rauschenberg, and other artists, despite the fact that Johns himself admittedly did not begin to concern himself intensively with Dadaism and the work of Marcel Duchamp until after the reviews appeared. January 1958 marked the opening of his first one-man show with Castelli, effectively flanked by an article in *Artnews*, which reproduced one of the exhibits, *Target with Four Faces*, 1955, on its cover. In previous years, *Artnews* had championed Abstract Expressionism. The decision to give so much support to an almost unknown artist working in such an innovative idiom, reflected the editors' desire for a generational and stylistic change. In addition to *Flag*, and *Target with Four Faces*, the show included *White Flag* (p. 8), *Flag on Orange Field* (p. 6), *Green Target* (p. 10), *Target with Plaster Casts* (p. 14), *Canvas* (p. 22), and *Book* (p. 23). A few

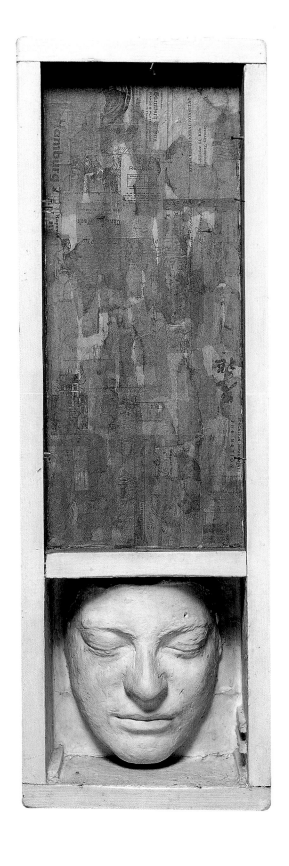

Canvas, 1956
Encaustic and collage on wood and canvas,
76.3 x 63.5 cm
Artist's collection

days after the vernissage, Alfred H. Barr, Jr., director of the Museum of Modern Art, and curator Dorothy Miller came to see the show. They acquired three paintings: *Target with Four Faces*, *Green Target*, and *White Numbers* (p. 12). It was certainly unusual for this internationally trend-setting New York museum to buy so many works by a young artist at once, but, as Miller later wrote, "they were inexpensive and they were just so remarkable." The MoMA, with Barr at its head, had recently organized an extensive touring exhibition under the title of "The New American Painting," which was shown in eight European cities and ended at the MoMA. In the wake of this show, which focused on the significance of abstract painting, the time for a reorientation had apparently come.

Beyond these three acquisitions, Barr also showed an initial interest in *Target with Plaster Casts* (p. 14). The piece, combining the target motif with a row of small boxes with hinged lids along the upper edge, was a continuation of the earlier *Construction with Toy Piano* (p. 18). With two exceptions, the boxes contain casts of body parts painted in different colors: a foot, the fragment of a face, a hand, a breast, an ear, a penis, and a heel; the greenish-black object at the right end of the row is a bone. The casts were taken from several different people, male and female. As Johns explained in an interview with Roberta Bernstein in 1980, the two works—*Construction with Toy Piano* and *Target with Plaster Casts*—were

designed to be viewed at close proximity, so viewers could manipulate the keys or lids. This aspect was lost when paintings assumed a museum character, but it had been important at the time of its creation. "I thought that what one saw would change as one moved toward the painting, and that one might notice the change as one moved toward the painting, and that one might notice the change and be aware of moving and touching and causing sound or changing what was visible."

The interrelationship of seeing, moving and touching is also alluded to in the target motif, which Johns saw as occupying "a certain kind of relationship to seeing the way we see and to things in the world which we see," as he explained to Walter Hopps in 1965. The target stands in symbolic relationship to the eye, which becomes especially clear in a few drawings and prints on the subject in which the black lines condense at the bull's-eye to suggest a pupil (p. 15). In addition, the target bears a sexual, traditionally female, connotation. A few commentators have noted a parallel with Francis Picabia's painting *The Spanish Night* (*La Nuit espagnole*, 1922), in which the silhouette of a woman is marked with two targets on belly and breast as well as several "bullet holes." Fred Orton thinks the most unorthodox feature of *Target with Plaster Casts* is the way it subverts the conventional definition of gender identity, the penis being the only element that can clearly be ascribed to the male body. Also, Johns's works can

Book, 1957
Encaustic on book and wood, 25.4 x 33 cm
Collection Margulies Family

For *Book*, Johns explained, he employed a book he had not intended to read but which had exactly the shape he wanted—much like the stencils for his letter paintings, which he liked for the fact that they were exactly what they were, as he told Leo Steinberg in 1962.

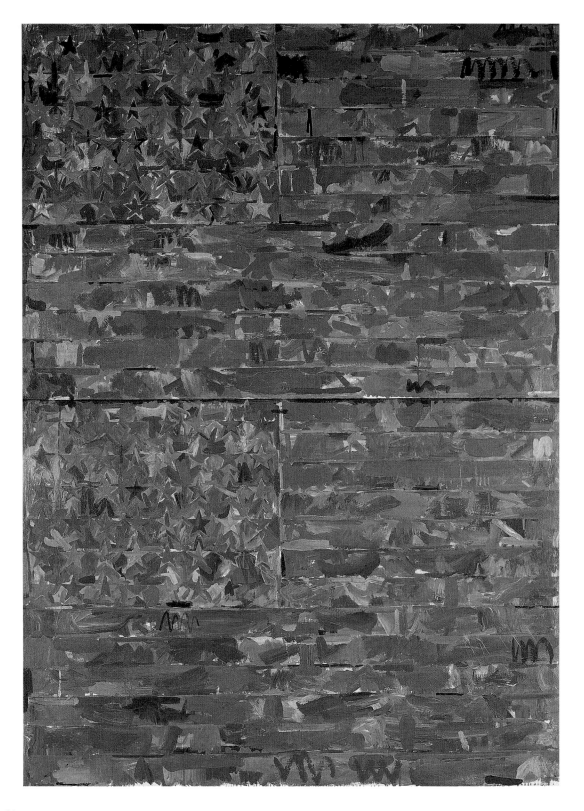

Two Flags, 1959
Encaustic on canvas, 199 x 145 cm
Vienna, Museum Moderner Kunst, Ludwig
Foundation, on loan from Ludwig Foundation,
Aachen

Johns dedicated a total of over 90 works to
the motif of the American flag. Its long rever-
beration in his oeuvre also included doublings
or multiplications of the motif, as in *Two Flags*
and *Three Flags* (pp. 26–27).

occasionally function as stand-ins for himself, as Crichton noted when, in a 1961
stage performance of a Cage concert, Johns sent a flower wreath in the shape of
a target rather than appearing in person. "A gesture rich with association …,"
wrote Crichton. "Wreaths are appropriate for holidays and funerals, triumphs
and tragedies; and Johns has always been fascinated with the idea of the stand-
in, with the surrogate, with one thing representing another."

At the time of its emergence, *Target with Plaster Casts* was considered too
provocative—at least with the boxes opened—for public display in a museum.
For "Artists of the New York School: Second Generation," the Jewish Museum
initially suggested that Johns close the lids over the penis cast and the bone,
which recalled the female genitals, in order to make the work more "enigmatic,"
a wish Johns apparently declined to fulfill, because the piece was ultimately not
included in the show. Its purchase for the MoMA, envisaged by Barr, likewise
miscarried because Johns declined to permanently close the lid over the penis.

Although the MoMA ordered *Flag* (p. 9) on approval, Barr feared that the
purchasing committee might find it "unpatriotic"—not least due to the art critics'
references to Dada and its critique of traditional middle-class values. So Barr
convinced the architect and collector Philip Johnson to acquire the picture and
later donate it to the museum. This is why *Flag* did not enter the MoMA collection
until 1973, on the occasion of Barr's retirement.

Seven years later, the Whitney Museum of American Art in New York marked
its fiftieth anniversary by acquiring another flag painting, *Three Flags*, for one
million dollars—the highest price yet paid for a work by a living American artist
(pp. 26–27). It was a happy coincidence that this occurred the very year Johns
himself turned fifty. "'I always wanted to sell a painting for a million dollars,' he
said in the 70's, after turning down an offer," wrote Crichton. There can be no
doubt that the audience and their view of Johns's *Flags* had changed since the
1950's. "So by the time you've imagined what the audience is, and formed your
ideas, it is going to be something else," he remarked to Peter Fuller in 1978.

With the success of his first show with Castelli, where all the works were sold
—except for *Target with Plaster Casts*, which Castelli himself acquired, and *White
Flag* (p. 8), which Johns kept—he suddenly stood at the focus of public attention.
"Jasper Johns, 29, is the brand new darling of the art world's bright, brittle avant-
garde," declared *Time Magazine* in 1959.

ILLUSTRATION PAGES 26–27:
Three Flags, 1958
Encaustic on canvas, 78.4 x 115.6 x 12.7 cm
New York, Whitney Museum of American Art.
Fiftieth Anniversary Gift of the Gilman Founda-
tion, Inc., The Lauder Foundation, A. Alfred
Taubman, an anonymous donor, and purchase

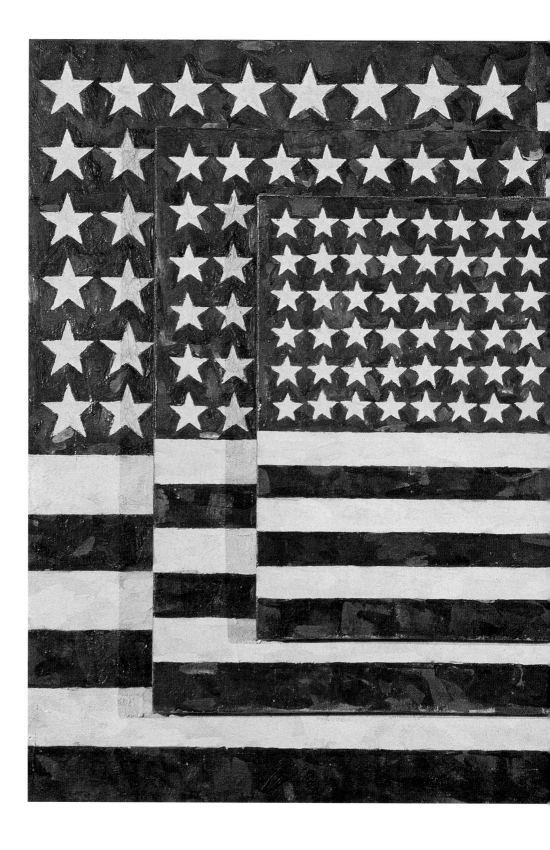

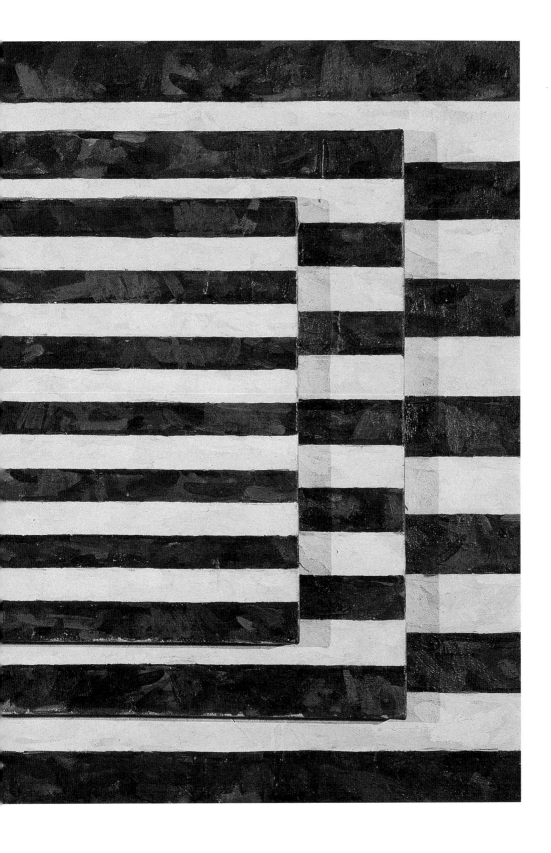

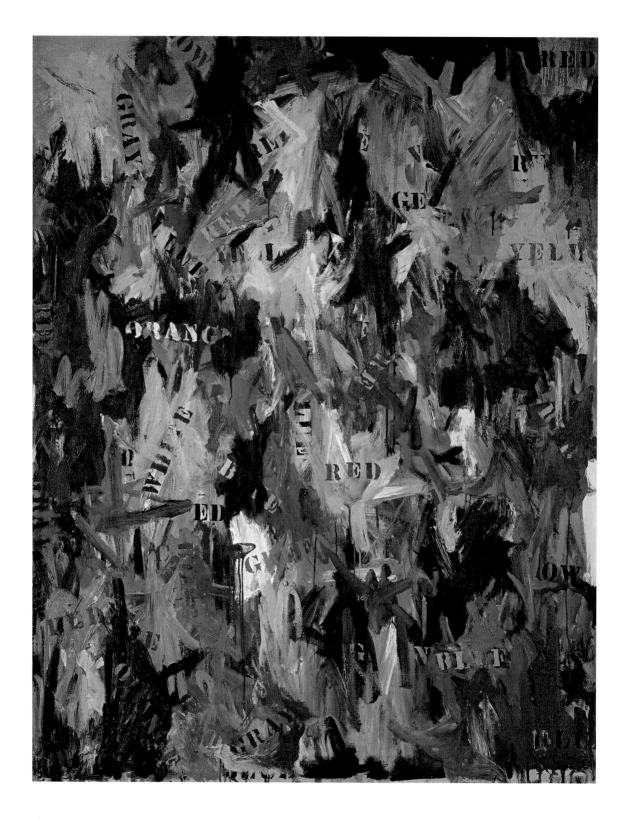

"In Some Other Light"

After developing a canon of easily recognizable motifs and scoring a remarkable success with his first show with Castelli in 1958, Johns set off in a new direction, though he himself did not view the change as "drastic." This reorientation was marked by *False Start* (p. 28). Johns switched from encaustic to oils, and his flat motifs with clearly demarcated color zones were supplanted by a multilayered paint application in which the sheaves of strokes, while still appearing controlled, had a looser and more "painterly" effect. Names of colors were stenciled on the paint surface, although they rarely corresponded to the actual color underneath. Occasionally, as with GREEN, the image contained no paint material that corresponded to the color designation. A conflict arose between language and visual perception. As Crichton remarked, *False Start* was concerned with a scientifically investigated phenomenon known as the Stroop effect. In experiments conducted in the mid 1930's, the psychologist J. Ridley Stroop had noted that people's recognition of a visually presented word was delayed when the content and color of that word did not coincide.

The title of Johns's painting was derived from a horse-racing poster he had seen at the Cedar Bar, a favorite artists' haunt and legendary gathering place of the Abstract Expressionists. As Johns told Walter Hopps in 1965, one of his reasons for choosing it was that *False Start* was different from his other paintings. The title, in other words, might allude to the possibility of viewers thinking the painting a "mistake" with respect to his earlier work. Yet *False Start* could equally well apply to the beginning of Johns's career. In horse racing, the term is used to describe the disqualified start of a race when one horse leaves the gate too soon. As critic Barbara Rose noted in this connection, Johns's early recognition was not necessarily accompanied by a true understanding of his art. Linking the picture's title with Johns's reaction to his sudden fame, Rose wrote, "A 'False Start' does not occasion a fresh start, but an attempt to retrieve a situation heading out of control."

At any rate, the presence of *False Start* in Johns's one-man show with Castelli in early 1960 discomfited some viewers, including Alfred Barr. The paint application, more "expressive" than that of his earlier paintings, seemed to refer back to Abstract Expressionism—if with a considerable dose of irony. As early as 1957, with *Drawing with 2 Balls*, Johns had begun a series of works that addressed the machismo and the notion of subjective expression generally associated with

The Critic Smiles, 1969
Lead relief with gold crown and pewter sheet,
58.4 x 43.1 cm
Cologne, Museum Ludwig, Ludwig Foundation

In the 1960's, Johns devoted a few of his objects to the activity of art critics. The works appear to suggest that critics occasionally neglect what Johns termed "the business of the eye."

ILLUSTRATION PAGE 28:
False Start, 1959
Oil on canvas, 170.8 x 137.2 cm
Collection Kenneth and Anne Griffin

Peter Fuller: "By the late 1950s, Abstract
Expressionism was looking more than a bit
tired, wasn't it?"
Jasper Johns: "Any ism will expire. By having
an ism you are separating it from other things.
Your attention has to deal with the entire field.
Things displace one another in one's interest."
JASPER JOHNS IN AN INTERVIEW WITH
PETER FULLER, 1978

Abstract Expressionism. *Painting with Two Balls* (p. 31) has a paint application similar to that of the earlier *False Start*. The work consists of three vertically arranged stretchers. Wedged between the middle and the top one—both slightly curved to prevent the canvas from wrinkling— are two painted balls. The result is a literal relationship of tension between image and object, something that Johns would investigate in numerous works to come. As he explained to Walter Hopps regarding *Target with Plaster Casts* (p. 14), "I think if there was any thinking at all, or if I have any now, it would be that if the painting is an object, then the object can be a painting … and I think that's what happened."

In the eyes of leading art critics of the 1950's and 1960's, this confounding of the media of painting and sculpture amounted to a sacrilege. The influential Clement Greenberg in particular saw the essence of modern art in a focus on the specific qualities of each medium. For painting this implied, in brief, abstraction, an emphasis on the flatness of the painting surface by means of "all-over" composition, and an avoidance of spatial illusion. Although Johns largely respected the flatness of the painting with his two-dimensional motifs—flags, targets, maps, etc.—he also frequently introduced sculptural elements and, in the case of *Painting with Two Balls,* actual three-dimensional objects which brought real space into the picture plane. And in another respect, too, this painting took a friendly but telling jibe at that myth of American painting which critics like Greenberg had so vehemently supported. The constricted "balls" represented an ironic comment on the supposed virility of the generation of artists around Jackson Pollock and Willem de Kooning, and their often ostentatious demonstration of masculinity in both their art and their lives. It would be equally plausible to view *Painting with Two Balls*—if we take "painting" as a verb—as a self-ironic reference to the author himself. In a certain sense, the two balls are abstractions of those castings of body parts Johns employed in works such as *Target with Plaster Casts*, and therefore might be read as an allusion to the supposed opposition of "abstract" and "figurative" art. A possible predecessor for the motif of balls, according to Nan Rosenthal and Ruth E. Fine, is Johns's oil-soaked graphite drawing of two oranges, done in 1954 (p. 20).

Painting with Two Balls is the first painting in which Johns inscribed title, date and signature at the lower edge by means of a stencil. This avoidance of the handwritten signature amounted to a further jab at conventional notions of artistic originality. In an often-quoted conversation between Johns and Leo Steinberg, published in 1962, Steinberg tried to track down the criteria underlying Johns's aesthetic decisions and their subjective basis. "The distinction I try to make between necessity and subjective preference seems unintelligible to Johns," Steinberg sighed. "I asked him about the type of numbers and letters he uses—coarse, standardized, unartistic: 'Do you use these letter types because you like them or because that's how the stencils come?' 'But that's what I like about them, that they come that way.'"

Johns's characteristic way of often replying to a question with another question or with an answer that threw the questioner back upon himself, soon took on the status of a genre in its own right—the "Johnsian Conversation." Johnsian conversations were frequently marked by great literalness, as an example reported by Michael Crichton from the 1970's indicates: "'He has the most literal mind of anyone I have ever met,' said a critic at a dinner. Johns sat at the head of the table, not listening … 'I think that literalness shows in his work,' the critic continued, more loudly. 'He is a very puzzling man. He always takes you exactly at your word.'—How else should I take you?' Johns said, looking down the table.

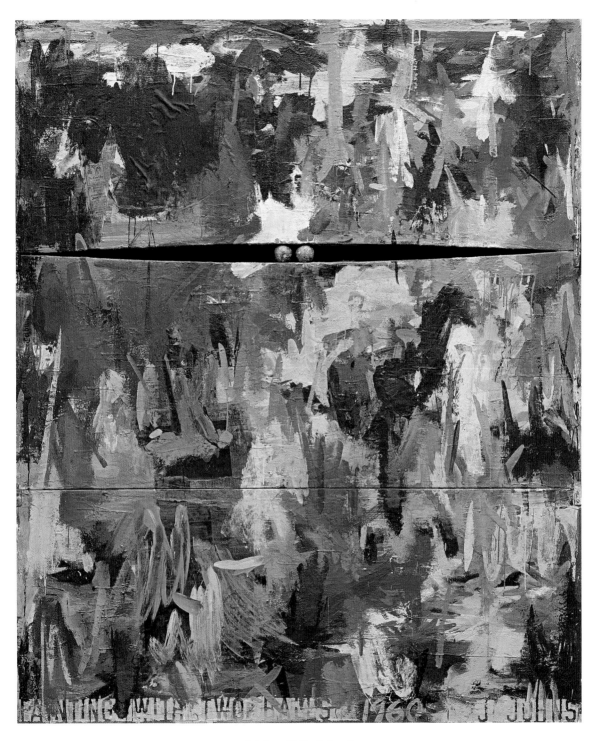

Painting with Two Balls, 1960
Encaustic and collage on canvas
with objects (three panels), 165.1 x 137.2 cm
Artist's collection

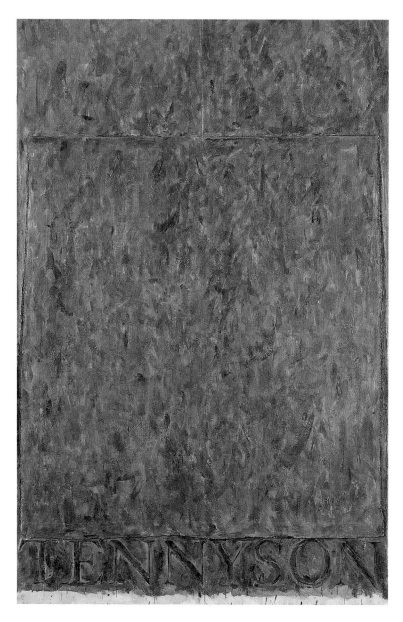

Tennyson, 1958
Encaustic and collage on canvas, 186.7 x 122.6 cm
Des Moines, IA, Des Moines Art Center.
Purchased with funds from the Coffin Fine
Arts Trust, Nathan Emory Coffin Collection
of the Des Moines Art Center, 1971

'Oh, you know what I mean, Jasper.'—'No,' Johns said seriously, 'I don't.'—
'There,' the critic said, triumphant. 'You see what I mean?'"

Johns's involvement with art critics and their writings formed the basis of
a series of works and texts, beginning with a publication in the journal *Arts* in
March 1959, which now marks the introduction to his collected writings. This
was a letter to the editor in which Johns reacted to a review by Hilton Kramer,
future chief critic of *The New York Times*. In the February issue of the magazine,
Kramer had mentioned several artists, and described Johns as "Dada which
is not Dada." Kramer's resumé of a series of visits to shows ended with the con-
clusion that the possibilities of the painting medium were exhausted. "Well,

thank God," Johns replied, "art tends to be less what critics write than what artists make." That same year emerged a drawing and a sculpture entitled *The Critic Smiles.* These show a toothbrush fitted with dental crowns instead of bristles, a motif of which Johns would make a further variation in a lead relief in 1969 (p. 29). The disquieting effect of the replacement of bristles by teeth recalls Surrealist objects, such as Meret Oppenheim's fur-lined teacup. In any event, *The Critic Smiles* seems to suggest that critics' urbane smiles cannot be real.

In 1958, a collector couple who had acquired his painting *Tennyson* (p. 32) gave Johns a copy of Marcel Duchamp's edition *Boîte-en-valise,* 1936–41, a portable miniature museum containing scaled-down reproductions of most all of his previous works. This opulent gift may have inspired Johns's involvement with Duchamp's idea of the ready-made and influenced his own approach to found objects. In addition, in December 1960 Johns published a review on Duchamp's *Green Box,* which contained working notes on his unfinished *Large Glass,* 1915–23. The *Green Box* had been published in a first, typographical edition in English translation in 1960. In his review, Johns quoted an excerpt from a passage dealing with the impossibility of transferring a "memory imprint" of one object to another, similar object: "To lose the possibility of recognizing / 2 similar objects / 2 colors, 2 laces / 2 hats, 2 forms whatsoever / to reach the Impossibility of / sufficient visual memory / to transfer from one / like object to another / the memory imprint."

Between 1958 and the early 1960's there emerged a group of works in which Johns transformed mundane objects like flashlights and light bulbs into "similar objects"—works of art—with the aid of various techniques. In *Flashlight I* (p. 34 bottom) he employed Sculpmetal for the first time, a vinyl resin mixed with powdered aluminum that was used principally in model building as a finish. Other objects were modeled in papier-mâché, plaster, and Sculpmetal (p. 34 top). In *The Critic Sees II* (p. 1)—an object in which, behind a pair of glasses, two mouths appear instead of eyes, the lips slightly open as if about to speak—Johns once again addressed the field of art criticism. Earlier, during the installation of a show at the Castelli Gallery, a critic had come in and asked Johns about the exhibits. He didn't pay any attention to what Johns said, the artist recalled. The critic asked him what he called "these things," and Johns said, "sculptures." He asked Johns why he called them sculptures when they were only casts. Johns replied that they were not casts, "that some had been made from scratch, and others had been casts that were broken and reworked. He said yes, they're casts, not sculpture." In 1978, Johns described *The Critic Smiles* and *The Critic Sees* to critic Peter Fuller as "cartoons." "Exactly," Fuller replied. "They are the kind of ideas a good cartoonist has a dozen times a week." "Of course. I hope so," said Johns.

Another of Johns's sculptures originated from an anecdote which the artist translated into art with his customary literalness. "I was doing at that time sculptures of small objects—flashlights and light bulbs," Johns told G. R. Swenson in a 1964 interview. Then I heard a story about Willem de Kooning. He was annoyed with my dealer, Leo Castelli, for some reason, and he said something like, 'That son-of-a-bitch; you could give him two beer cans and he could sell them.' I heard this and thought, 'What a sculpture—two beer cans.' It seemed to me to fit in perfectly with what I was doing, so I did them—and Leo sold them." (p. 35)

On first glance, the two beer cans, cast in bronze and painted with oils, appear symmetrically arranged on the low base, putting one in mind of the 1954 still life of two oranges (p. 20). This repetition of a motif, found for the first time in

Tennyson, 1958
Ink on paper, 37,8 x 25,1 cm
Artist's collection

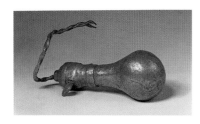

Lightbulb II, 1958
Sculpmetal, 7.9 x 20.3 x 12.7 cm
Philadelphia, PA, Philadelphia Museum of Art.
Artist's collection

At the end of the 1950's, Johns made his first sculptures based on everyday objects such as flashlights, electric bulbs, and beer cans. These were not so much anonymous consumer commodities as things taken from his immediate personal surroundings, things that had long been present in his studio.

Two Flags (p. 24), reminded Riva Castleman of Zen Buddhism, in which ritual repetition plays a role in meditation. The labels turned towards the center augment the impression of a symmetrical mirror image. On closer scrutiny, however, the can on the left turns out to be open and hollow, while that on the right is closed and solid. Nor are they exactly the same size, and their lids are differently treated. The original for the left-hand can with its three rings came from Florida, the other from New York. They have the appearance of manufactured products, yet simultaneously look handmade. Roberta Bernstein supposed that Johns employed Ballantine Ale cans because their color schemes recalled traditional bronze. As Alan R. Solomon aptly noted, they had the disquieting effect of sculptures that gave the impression of objects trying to become sculpture. Moreover, one might add in view of the title, *Painted Bronze*, they give the impression of sculptures trying to become painting—or vice versa. In the case of his earlier paintings, Johns had expected people to view them as objects— like radiators on the wall. The making of three-dimensional objects apparently caused him some discomfiture with regard to his self-confidence as an artist, as John Cage once recalled. As they were talking in a room that contained both paintings and sculptures, and quite cognizant of the difference between them, Cage reported, Johns suddenly laughed when he heard what he had just said ("I am not a sculptor"). Cage felt lost, then Johns said, in a tone as if his friend were a jury, "But I *am* a sculptor, am I not?" From Johns's point of view, *Painted Bronze* evidently represented a sculpture about painting, just as *False Start* (p. 28) was a painting about colors.

This is even more obviously true of a further sculpture with the title *Painted Bronze (Savarin Can with Brushes)*. Its model, like the beer cans, came straight from the studio, as Johns explained to Walter Hopps (p. 37). Johns translated a Savarin coffee can with contents—brushes in turpentine—into a plaster, from which a bronze casting was made. This he painted in a way that made it very similar to the "original." The coffee brand was named after the French gastronome Jean Anthelme Brillat-Savarin, who went down in the history of the art and science of good eating with his *The Physiology of Taste*, 1826. Johns's interest in the French author surely had to do with more than the fact that he himself was, and

Flashlight I, 1958
Sculpmetal on flashlight and wood,
13.3 x 23.2 x 9.8 cm
Collection Sonnabend

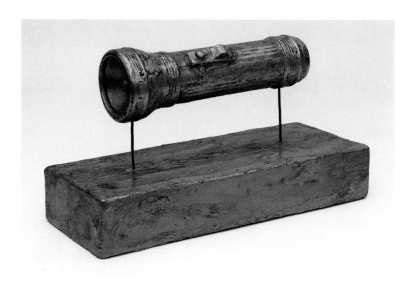

Painted Bronze, 1960
Oil on bronze, overall: 14 x 20.3 x 12 cm;
two cans: each 12 x 6.8 cm diameter;
base: 2 x 20.3 x 12 cm
Cologne, Museum Ludwig, Ludwig Foundation

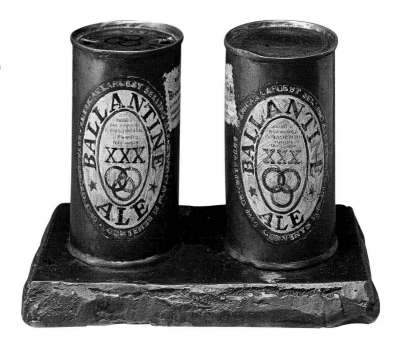

still is, an excellent cook. Brillat-Savarin advocated a refinement of our ability to distinguish different tastes. In one of his aphorisms he declared that a true gourmet who had eaten a partridge could say on which leg it used to sleep. A well-developed ability to distinguish was also demanded of the viewers of *Painted Bronze*, as Walter Hopps noted in 1965. One of the most remarkable things about the work, Hopps told Johns, was that the original brushes probably looked almost exactly the same as they did in the bronze sculpture. In no other work, not even the beer cans, had Johns embarked on the arduous process of making a sculpture while restoring a state that came extremely close to the original. He liked the possibility, Johns replied, that one state could be mistaken for the other, but also that, after brief scrutiny, it became very clear that the one was not the other. In view of the many and interwoven relationships between the mundane objects from Johns's surroundings and his sculptures, Cage brought another comparison into play. As Johns once told him, such objects had repeatedly appeared to him years before in dreams, in which the things and happenings he saw could no longer be distinguished from those seen in the light of day. At the same time, Cage emphasized the difference between Duchamp's ready-mades—objects usually taken straight from the everyday world and declared to be art—and Johns's objects: "The cans of ale, *Flashlight*, the coffee can with brushes: these objects and the others were not found but were made. They were seen in some other light than that of day. We no longer think of his works when we see around us the similar objects they might be thought to represent. Evidently these bronzes are here in the guise of works of art, but as we look at them we go out of our minds, transformed with respect to being."

Due to his motifs taken from the mundane world, Johns is often viewed as a predecessor of Pop Art. The term Pop became current on the New York art scene at the latest after "The New Realists," a 1962 show at the influential Sidney Janis Gallery. An obvious trait of the new direction, which first surfaced in England,

"The demand for his work exceeds the supply. The information that he has stretched a canvas, if, that is, it was not already commissioned, produces a purchase."
JOHN CAGE, 1964

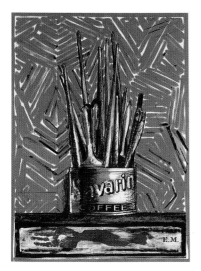

Savarin, Universal Limited Art Editions,
1977–1981
Lithograph, 127.6 x 97.3 cm
New York, The Museum of Modern Art.
Gift of Celeste Bartos

ILLUSTRATION PAGE 37:
Painted Bronze (Savarin Can with Brushes),
1960
Oil on bronze, 34.3 x 20.3 cm diameter
Philadelphia, PA, Philadelphia Museum of Art.
Artist's collection

was the employment of trivial imagery from everyday life, especially advertising and consumer commodities, television and the print media. This was accompanied by a tendency to a graphic reduction of motifs. In 1963 Johns participated in important shows that represented the new style, including "The Popular Image Exhibition," at the Gallery of Modern Art in Washington, D. C., and "Six Painters and The Object," at The Solomon R. Guggenheim Museum, New York. The latter was curated by Lawrence Alloway, who was among the first to use the term "Pop Art," as in his 1958 essay on art and the mass media. "Six Painters and The Object" included works by Johns, Jim Dine, James Rosenquist, Robert Rauschenberg, Andy Warhol, and Roy Lichtenstein. At about the same time, in the magazine *Artnews*, the critic Gene R. Swenson published a series of interviews with eight artists then associated with Pop, including Johns, Dine, Lichtenstein, Warhol, Rosenquist, Robert Indiana, and Tom Wesselmann. To the introductory question, "What is Pop Art?" Johns replied with a question of his own: "There has been an attempt to say that those classified under that term use images from the popular representations of things. Isn't that so?" When Swenson remarked that his works had been shown in exhibitions under that label, Johns demurred. "I'm not a Pop artist!" he exclaimed. "Once a term is set, everybody tries to relate anybody they can to it because there are so few terms in the art world. Labeling is a popular way of dealing with things."

In fact, the Ballantine Ale and Savarin Coffee cans would remain Johns's only direct borrowings from the world of brand-name goods. And they exhibited marked differences from Warhol's series of Campbell's Soup cans, begun in 1962. The Pop Art objects related to buying and selling, whereas Johns's objects retained a definite aspect of ownership, as Kirk Varnedoe observed. This is underscored by the fact that the bronze casting of the brushes in the Savarin can is still in the artist's own collection. A version of the painted bronze Ballantine cans was sold by Castelli—which, as it were, was part of its conception—and a slightly modified version is likewise in Johns's possession.

In 1963, *Newsweek* declared that at age 32, Jasper Johns was probably the most influential younger painter in the world. Art historians generally reduce his role to that of a missing link between Abstract Expressionism and the subsequent tendencies of the 1960's, such as Pop, Minimalism, and Conceptual Art. Not surprisingly, Johns again and again rejected such classifications as misunderstandings, or "mere 'sociology.'" "If an artist makes something—or if you make chewing gum and everybody ends up using it as glue, whoever made it is given the responsibility of making glue, even if what he really intends is chewing gum," as he explained to Swenson. Seen in this light, Johns's strong and multifarious influence on a younger generation of painters and sculptors such as Robert Morris, Richard Serra, Eva Hesse, and Kiki Smith might be described as the result of a productive interpretation. Artists like Brice Marden, Mel Bochner, and Dan Flavin paid homage to Johns by incorporating his name in titles of their works. Occasionally, as in Bruce Nauman's case, Johns's art additionally functioned as a filter through which the influence of Duchamp was received. "I loved de Kooning's work," Nauman said in 1988, "but Johns was the first artist to put some intellectual distance between himself and his physical activity of making paintings." The Nauman films *Bouncing Balls* and *Black Balls*, 1969, show close-ups of a hand moving the artist's testicles up and down or painting them black. These images have a "literalness" which brings Johns's *Painting with Two Balls* (p. 31) up to date and ironically takes it ad absurdum.

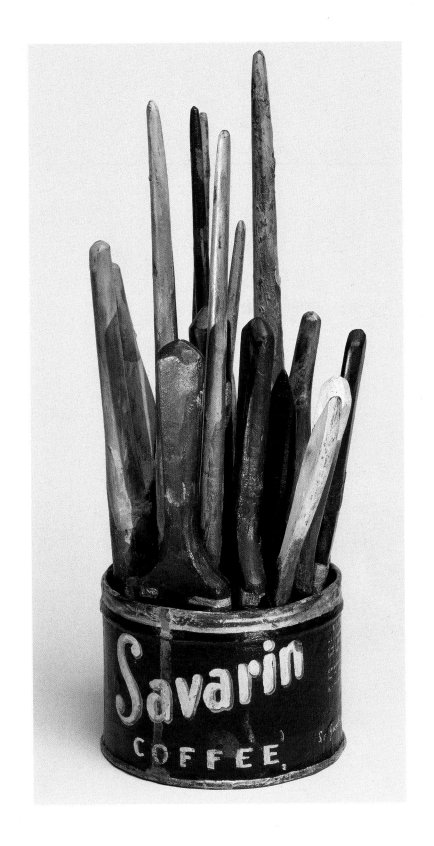

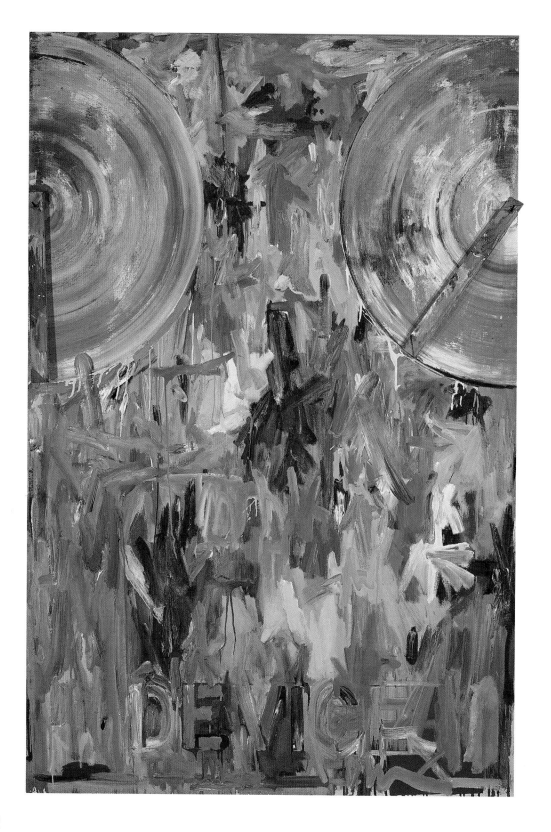

"In Memory of My Feelings"

The year 1961 is frequently described as the turning point in Johns's develop-
ment. His success enabled him to retain a certain distance from the New York
art world. He bought a house on Edisto Island off the coast of South Carolina,
where he spent several months a year over the following years. In the early 1960's,
according to Michael Crichton, Johns's paintings became "more self-referential,
more difficult, more disturbing." In the eyes of Leo Steinberg, who saw them
shortly after their execution, these were works of an artist "past 30 [who] dares
to be frankly autobiographical."

Many of these paintings were dominated by a range of gray tones like those
that had already appeared in *Canvas* (p. 22), and *Gray Alphabets* (p. 13), Johns's
first letter painting. *Canvas*, moreover, was the first picture to which the artist
affixed an actual canvas stretcher—a device that recurred in 1960's paintings
such as *According to What* (pp. 50–51), and *Fool's House* (p. 41). In this way, Johns
put his conception of the painting medium literally into the picture. "One of the
extreme problems of paintings as objects," he explained to Crichton, "is the other
side—the back. It can't be solved; it's in the nature of the work." Apart from this
logical, formal factor, later commentators also saw an expressive value in this
device: "The arrangement is a melancholy one, evoking refusal, reversal, absence,
silence," as the curator Joan Rothfuss wrote in 2003.

The monochrome gray of the early paintings, according to Johns, was
intended to avoid the "emotional and dramatic quality of color." "The gray
encaustic paintings seemed to me to allow the literal qualities of the painting
to predominate over any of the others." In conversation with Crichton, Johns
even described himself as a weak colorist who had greater difficulty than most
people in distinguishing colors: "I was working on a colored numbers painting.
When I worked on it for longer than a minute, the entire painting would turn
gray to me. I couldn't see any of the colors, and I would have to stop." Beyond
this physiological experience, the gray encaustic alluded to René Magritte, an
artist Johns admired, who in the early 1950's had done a series of paintings in
which the objects appeared petrified, turned to gray stone.

As in the early *Painting with Two Balls* (p. 31) at the beginning of the
1960's—inspired by Duchamp's *Green Box*—Johns frequently integrated lin-
guistic elements into his pictures. This coincided with his interest in the writings
of the Austrian philosopher Ludwig Wittgenstein. *Fool's House* (p. 41) is one of

Souvenir, 1964
Encaustic on canvas with objects, 73 x 53.3 cm
Artist's collection

Disappearance II, 1961
Encaustic and collage on canvas, 101.6 x 101.6 cm
Toyama, The Museum of Modern Art

In fall 1961, a series of paintings emerged which
were dominated by shades of gray and differed
from earlier works in having narrative or allu-
sive titles. The critic Leo Steinberg viewed them
as "frankly autobiographical."

the first paintings done at that period. It shows in a dual way—as object
and concept—a series of household and studio utensils: a towel, a painting
stretcher, a cup, and a broom doubling as an oversized brush, whose move-
ment across the picture surface is evoked by horizontal brushstrokes. The title
was applied with a stencil in a way as to suggest that the canvas has a three-
dimensional, cylindrical shape. In later, multipartite works like *Voice 2* (pp. 42–43),
Johns would vary this effect by envisaging different possibilities of hanging—
the sequence of panels being defined such that any of them could be put at the
beginning.

Johns's 1960's paintings are considered difficult to read. "Their meanings, if
decipherable," wrote the critic Barbara Rose, "lie entirely within the world creat-
ed on canvas or paper. Within this world, not the identity of the objects, but
the nature of their relationship counts." Adopting a term of Wittgenstein's, one
might speak of a "private language" in these paintings, one whose meanings, ini-
tially known only to the individual who speaks it, would expand conventional
language. "There seems to be a sort of 'pressure area' 'underneath'… language
which operates in such a way as to force the language to change," Johns noted in
a sketchbook in 1963–64. "(I'm believing painting to be a language, or wishing
language to be any sort of recognition.) If one takes delight in that kind of
changing process one moves toward new recognitions (?), names, images."

In addition to an involvement with Wittgenstein's writings and those of the
media theoretician Marshall McLuhan, Johns drew stimuli from his reading of,
and occasional collaboration with, other writers. Back in 1958–59, in the canvas

ILLUSTRATION PAGE 41:
Fool's House, 1962
Oil on canvas with objects, 182.9 x 91.4 cm
Collection Jean Christophe Castelli

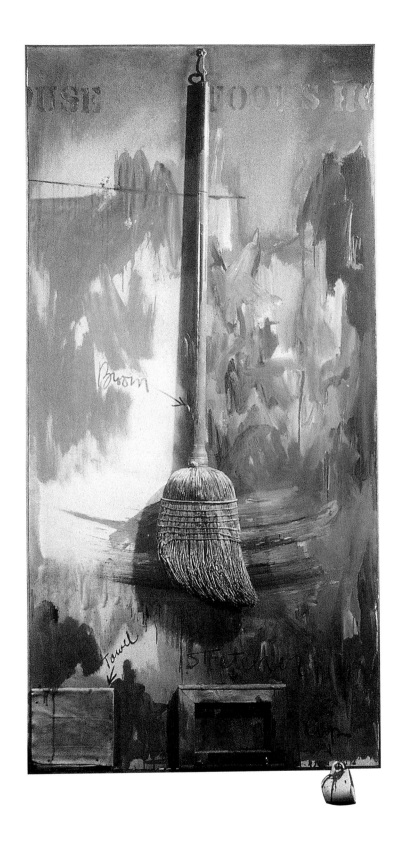

Voice 2, 1968–1971
Oil and collage on canvas (three panels),
overall dimensions 182.9 x 411.4 cm; each panel
182.9 x 127 cm; 15 cm between each panel
Basel, Öffentliche Kunstsammlung Basel,
Kunstmuseum

The three elements of *Voice 2* are conceived such
that they can be hung in varying sequences.
They are based on the idea that, in conjunction,
they form a continuous cylindrical surface –
a way of overcoming the two-dimensional
character of painting.

and two drawings titled *Tennyson* (pp. 32–33), he had already paid homage to
the Victorian poet Alfred Tennyson, whom T. S. Eliot called "the great master of
metric as well as of melancholia." In several works of 1963, Johns alluded to Hart
Crane, an American poet who died young, and his metaphorically charged,
complex long poem *The Bridge*, 1930. Crane lived in Brooklyn in the early 1920's,
and the Brooklyn Bridge formed one of the central motifs of his poem, con-
ceived as a reply to Walt Whitman's *Leaves of Grass*, 1855, and T. S. Eliot's *The
Waste Land*, 1922. Crane, who had been brought up in the Christian Science
tradition, experienced his homosexuality as conflictive, and at the same time as
the source of his calling as a poet. He committed suicide in 1932, by jumping
from an Atlantic liner into the Gulf of Mexico.

The extended arm in *Periscope (Hart Crane)* might allude to the arm of
the drowning man (p. 45). Possible points of reference in art history could be
Cézanne's *Bather with Outstretched Arms* (*Baigneur aux bras écartés*, c. 1883),
which is in Johns's collection, Leonardo da Vinci's renowned drawing *Propor-
tional Figure after Vitruvius,* c. 1485–90, or depictions of Christ crucified. At
the same time, the boardlike arm functions as a scraper or straightedge that de-
scribes a semicircle —recalling a target, an eye, or Duchamp's *Rotoreliefs*, 1935.
Periscope (Hart Crane) "is the least physical painting of any work I've done
recently," Johns explained to Billy Klüver in 1963. "At least, I hope so. Physicality
is purely illusionistic, or tends to be illusionistic. One might or might not think
that circle has been made by that hand."

In the 1960's, Johns frequently integrated instruments such as rulers, color scales, and thermometers in his works. These toyings with the idea of physical measurement were inspired in part by certain of Duchamp's works, which take scientific measurement ad absurdum (p. 38). "I suppose," said Johns in 1993 to Bryan Robertson and Tim Marlow, that "that has to do with an interest in the idea of measurement and with the play of what measures against that which can or cannot be measured."

The title *Periscope* takes up a passage from *The Bridge* devoted to Cape Hatteras on the North Carolina coast: "A periscope to glimpse what joys or pain / Our eyes can share or answer." *Periscope* alludes to an optical instrument that not only supports what Johns called "the business of the eye," but can be associated with mental introspection. Accordingly, the color designations RED, YELLOW and BLUE in *Periscope* and other works have been interpreted as allusions to emotional states, as when Mark Rosenthal read YELL in YELLOW.

A series of Johns's 1960's works emerged in the context of his friendship with the author and curator Frank O'Hara, whom Johns had met around 1957. From 1946 onwards, O'Hara published plays, poems and short stories, and in the mid 1950's wrote articles and reviews for *Artnews*. As a member of the International Program at the Museum of Modern Art, he organized the museum's influential international traveling exhibitions. The literary texts of O'Hara and befriended writers who were active outside the academic literary establishment frequently emerged in the context of the art scene, and found their first audiences there.

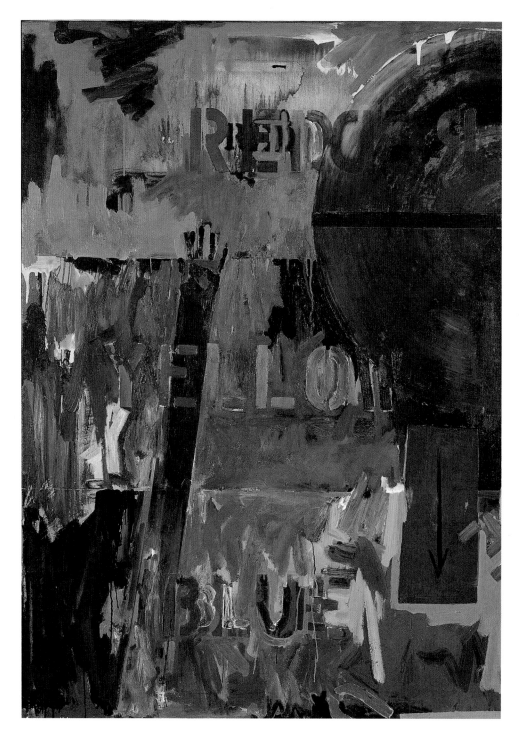

Land's End, 1963
Oil on canvas with wood, 170.2 x 122.6 cm
San Francisco, CA, San Francisco Museum of Modern Art.
Gift of Harry W. and Mary Margaret Anderson

Periscope (Hart Crane), 1963
Oil on canvas, 170.2 x 121.9 cm
Artist's collection

***Map (Based on Buckminster Fuller's
Dymaxion Air Ocean World)***, 1967–1971
Encaustic and collage on canvas (22 parts),
500 x 1000 cm
Cologne, Museum Ludwig, Ludwig Foundation

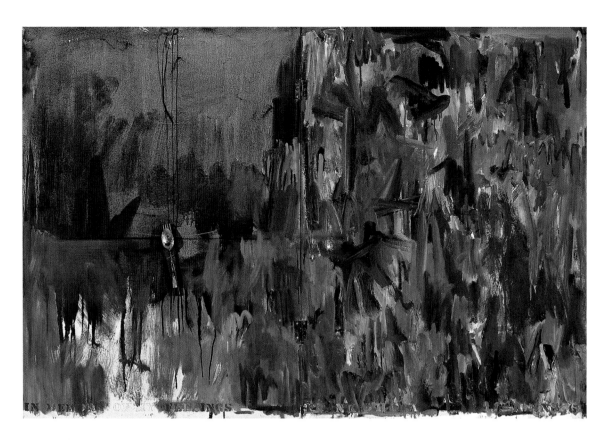

In Memory of My Feelings – Frank O'Hara,
1961
Oil on canvas with objects (two panels),
101.6 x 152.4 cm
Chicago, IL, Museum of Contemporary Art.
Partial gift of Apollo Plastics Corporation,
courtesy of Stefan T. Edlis and H. Gael Neeson

Galleries like Tibor de Nagy and the Eighth Street Club funded publications and sponsored readings. Johns and O'Hara planned a portfolio of images and poems, yet only one lithograph, *Skin with O'Hara Poem* (p. 49 top), was ultimately made. From the nine poems provided by O'Hara, Johns chose "The clouds go soft," which evokes transitoriness in everyday language. The basis for Johns's lithograph was a series of drawings in which he transferred impressions of his face, rubbed with oil, onto a sheet of paper and rendered these visible by means of graphite dust. The translation of a three-dimensional body into a two-dimensional medium is a formal factor that links *Skin with O'Hara Poem* with his works based on maps (pp. 46–47). Yet the impression of his face and hands on paper—combined with O'Hara's words—called up associations with imprisonment and death. Max Kozloff, moreover, brought the Christian iconography of "Veronica's veil" into play—the cloth with which, according to medieval legend, Christ dried the blood and sweat from his face during the Passion and that retained his "true image" (Lat. *vera icon)*. To Kozloff, Johns's impressions on paper suggested "ghostly images of a man's head and hands pressing against the page from behind … It is Veronica's veil in modern dress, ending up in a paradox about the nature of the picture plane (opaque or transparent, glass or mirror)…"

Intimations of finiteness and death are also found in a further work in which Johns quoted an O'Hara poem, *In Memory of My Feelings—Frank O'Hara* (p. 48). O'Hara, who had intimate relations with both men and women, dedicated a poem titled "In Memory of My Feelings" in 1956 to the artist Grace

Skin with O'Hara Poem, Universal Limited
Art Editions, 1965
Lithograph, 55.9 x 86.4 cm
New York, The Museum of Modern Art.
Gift of the Celeste und Armand Bartos
Foundation

ILLUSTRATION CENTER:
Memory Piece (Frank O'Hara), 1961–1970
Wood, lead, rubber, sand, and Sculpmetal,
15.2 x 17.2 x 33 cm (closed)
Artist's collection

ILLUSTRATION BOTTOM:
Edisto, 1962
Charcoal and graphite pencil on paper,
53.3 x 68.6 cm
Artist's collection

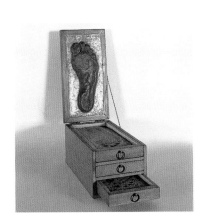

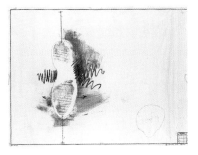

Hartigan, his companion of many years; their relationship broke up in 1960.
Authors like Fred Orton accordingly associated *In Memory of My Feelings—
Frank O'Hara* with the end of Johns's relationship with Robert Rauschenberg.
Under the paint layers on the right panel, as X-rays have revealed, there is a
schematically painted skull. At the lower edge of the two-part canvas held to-
gether by hinges, likewise concealed by later paint layers, the words DEAD MAN
are stencilled. "A DEAD MAN / Take a skull / cover it with paint / rub it against
canvas," noted Johns around 1960–61 in his sketchbook. From the left half of the
tableau hang a spoon and fork, tied together, on a wire. In a 1965 interview with
David Sylvester, Johns emphasized that he used "real things as painting. That is
to say, I find it more interesting to use a real fork as painting than to use painting
as a real fork." When Nan Rosenthal and Ruth E. Fine asked him in 1989 about
the repeated appearance of knives, forks and spoons in his works, Johns replied,
"My associations, if you want them, are cutting, measuring, mixing, blending,
consuming—creation and destruction moderated by ritualized manners."

It was only after the death of O'Hara in an automobile accident on Fire Island
in 1966 that Johns finished a work he had conceived back in 1961. It was based
on a rubber casting of an impression of O'Hara's left foot, and two drawings.
The one, *Edisto* (p. 49 bottom), shows the impression and contour of a shoe sole,
vertically suspended on two threads, with two horizontal arrows that seem to in-
dicate rotation. The seashell possibly alludes to the beach on Edisto Island, where
O'Hara's footprint was made. In 1963 the poet, apparently in memory of the
project, wrote in a letter-poem to Johns, "when I think of you in South Carolina
I think of my foot in the sand." The length of the shoe sole, as Nan Rosenthal
notes, in fact literally conforms to "one foot," the American measure of length,
thus once again referring to "the play of what measures against that which can
or cannot be measured." The other drawing—*Memory Piece (Frank O'Hara)*,
1961, has the character of a construction drawing for the fabrication of an object,
showing a footprint and the plan of a box with three drawers. The design would
not be executed until 1970 (p. 49 center). When the lid is closed on the upper-
most of the three sand-filled drawers, the rubber cast of the footprint leaves an
impression in the sand.

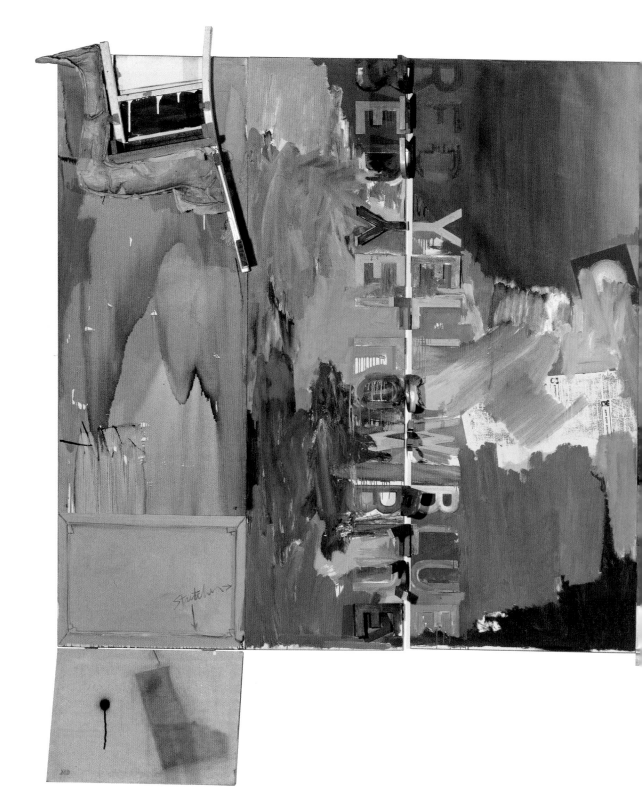

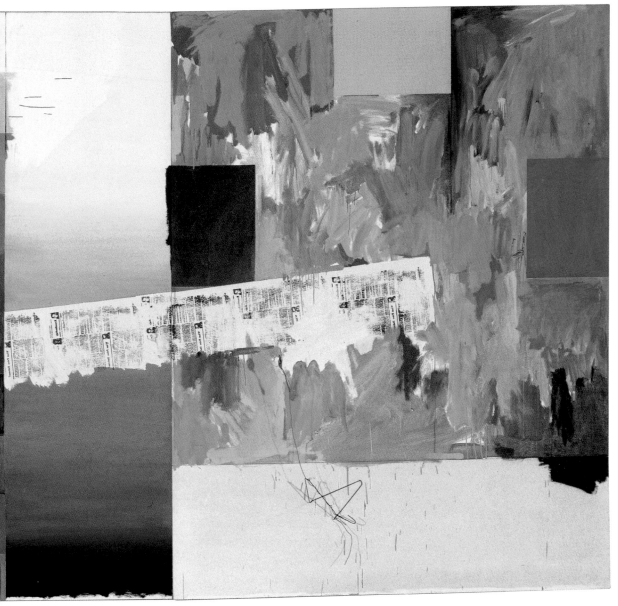

According to What, 1964
Oil on canvas with objects (six panels),
223.5 x 487.7 cm
Private collection

According to What, Johns's largest format to
that point, was painted in the year when two
retrospectives of his work were shown in
several international museums. It contains
numerous quotes of and allusions to earlier
works. At about this time Johns also began to
keep sketchbooks in which he recorded ideas
and reflections about new projects.

Cups 4 Picasso, Universal Limited Art Editions, 1972
Lithograph, printed in color, 56.5 x 81.9 cm
New York, The Museum of Modern Art. Gift of Celeste Bartos

In view of this subject, Roberta Bernstein was put in mind of Duchamp's "still life" *Torture-Morte*, 1959, a painted plaster cast of a right footprint with eleven flies perched on its underside. Beyond this, a connection can be made with another sort of torture, to which Rauschenberg had referred in his 1959–60 illustrations to Dante's *Divine Comedy*. In the seventh circle of Hell, Dante describes his encounter with the souls of the dead who are suffering for their infringements "against Nature and the grace of God." As the art historian Jonathan Katz remarks, one of the illustrations relates to the passage in the text describing the punishment of sodomites, who are condemned to walking barefoot over sand made red hot by a rain of fire. Rauschenberg's corresponding illustration shows the contour of a foot. It is safe to assume that Johns was aware of Rauschenberg's involvement with the *Divine Comedy* and the emergence of his illustrations, and that an association with the "sodomites in the rain of fire" might have played a role in Johns's *Memory Piece (Frank O'Hara)*. The object gained further facets by the fact that it was finished only posthumously—and that O'Hara died on Fire Island.

While works such as *In Memory of My Feelings—Frank O'Hara* (p. 48) and *Periscope (Hart Crane)* (p. 45) were often searched for autobiographical references, Johns himself was skeptical about the part played by conscious intentions in his artistic thinking and acting. In a 1965 interview with David Sylvester, he appealed to his audience to draw their own conclusions: "I think a painting should include more experience than simply intended statement. I personally would like to keep the painting in a state of 'shunning statement,' so that one is left with the fact that one can experience individually as one pleases; that is, not focus the attention in one way, but to leave the situation as a kind of actual thing, so that the experience of it is variable."

Like *Periscope*, *Watchman* (p. 2) addresses the process of perception. In his sketchbook notes on this work, Johns distinguished between a "watchman" and a "spy," evidently envisaging both artist and viewer as capable of assuming either role: "The spy must be ready to 'move,' must be aware of his entrances and exits. The watchman leaves his job & takes away no information. The spy must

ILLUSTRATION PAGE 53:
Decoy, 1971
Oil on canvas with brass grommet,
182.9 x 127 cm
Collection Mr. and Mrs. S. I. Newhouse

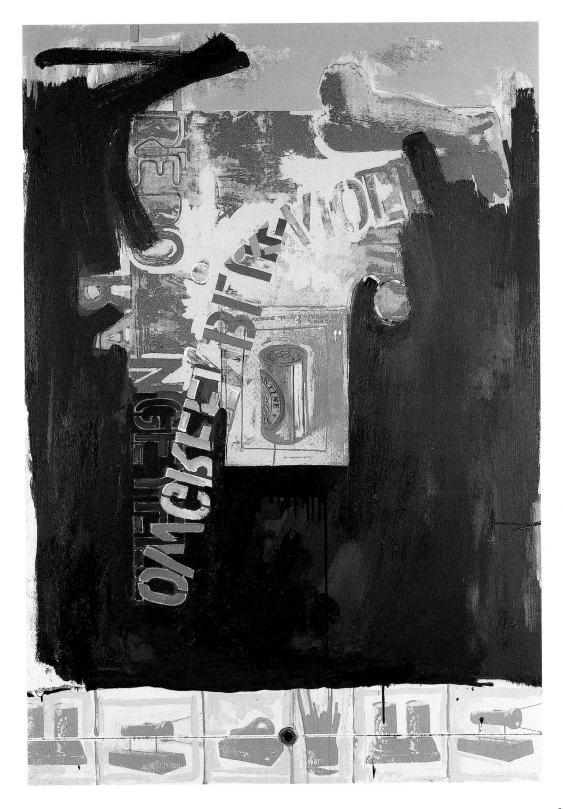

Harlem Light, 1967
Oil and collage on canvas (four panels),
198.1 x 436.8 cm
Private collection

In 1967, Johns expanded his formal repertoire by
the flagstone motif, which he had fleetingly seen
that year on the wall of a building while driving
through Harlem. His attempt to locate this wall
afterwards failed, so he finally reconstructed it
from memory.

Untitled, 1972
Oil, encaustic and collage on canvas with objects
(four panels), 183 x 490 cm
Cologne, Museum Ludwig, Ludwig Foundation

ILLUSTRATION PAGES 58–59:
Scent, 1973–1974
Oil and encaustic on canvas (three panels),
182.9 x 320.6 cm
Aachen, Ludwig Forum für Internationale Kunst

remember & must remember himself & his remembering. The spy designs himself to be overlooked. The watchman 'serves' as a warning. Will the spy & the watchman ever meet? In a painting named <u>Spy</u>, will he be present? The spy stations himself to observe the watchman."

 In the monumental *According to What* (pp. 50–51), his largest work to that point, Johns included variations of elements from *Watchman*, such as the cast of a leg and parts of a chair, as well as aspects of earlier works. In fact, as Varnedoe noted, *According to What* represents a compendium of his previous work. The activities Johns associated with knife, fork and spoon—"cutting, measuring, mixing, blending, consuming—creation and destruction moderated by ritualized manners"—at the same time characterized his working methods. The fragmentary title signals the lack of a comprehensive point of reference that would bring together the separate parts of the image. It alludes to the likewise elliptic title of Duchamp's *Tu m'*, 1918, the work with which he took leave of painting forever. Johns frequently emphasized his impression that his work was "too much of a piece," a notion that *According to What* seems to contradict. Perhaps one reason why the work has the appearance of a retrospective in miniature is

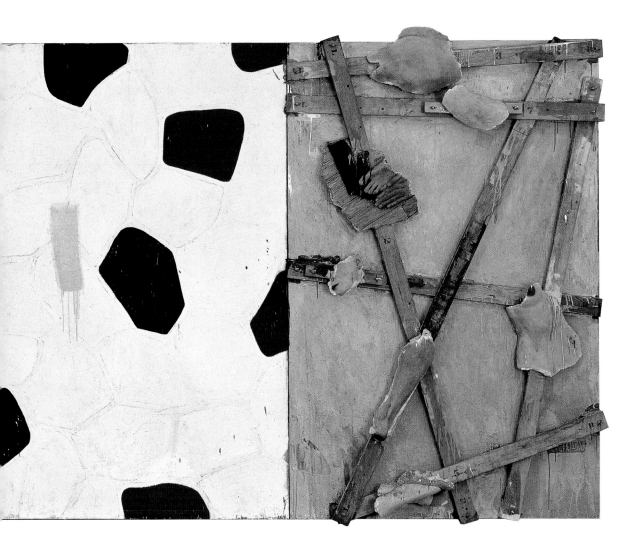

because it emerged at the time of Johns's retrospective at the Jewish Museum. This exhibition provided a review of the years 1954–64, and, as the critic Irving Sandler noted, it put Johns—due to his great influence on other directions in art—in the paradoxical position of an "Old Master" at the age of 33.

Over the following years, Johns expanded his repertoire by two elements that he traced back to fleeting perceptions—glances out the window of a moving car. In the large-format, multipartite *Harlem Light* (pp. 54–55), he introduced the flagstone motif, which he had noticed in a mural in Harlem. Every effort to locate this motif during a second drive proved fruitless, so Johns reconstructed the flagstone pattern from memory. Speaking with Crichton, Johns described the employment of this non-artistic element as a way out of a dilemma: "Whatever I do seems artificial and false, to me. They—whoever painted the wall—had an idea … I wanted to use that design. The trouble is that when you start to work, you can't eliminate your own sophistication. If I could have traced it I would have felt secure that I had it right. Because what's interesting to me is the fact that it isn't designed, but taken. It's not mine." This quality of being "not his," and its flatness, link the flagstone motif with the American flag. Yet its appropriation

Corpse and Mirror II, 1974–1975
Oil on canvas (four panels),
146.4 x 191.1 cm including painted frame
Artist's collection

"I think artists are the elite of the servant class."
JASPER JOHNS, 1978

also illustrates the impossibility described by Duchamp "of / sufficient visual memory / to transfer from one / like object to another / the memory imprint." And, as Johns remarked, it was equally impossible to escape his own sophistication— not to mention that of his interpreters. Roberta Bernstein, for instance, compiled an imaginary museum as a potential storehouse on which Johns's imagery might have drawn. It contained a work by Magritte that could just as well have served as a model for the artist's flagstones: *The True Meaning* (*Le sens propre*, 1929), which was in Rauschenberg's collection. Yet, as Johns told himself in a note of 1964, "Avoid a polar situation. Think of the edge of the city & the traffic there."

The second motif that Johns derived from a visual impression had during an automobile ride was crosshatching, which first appeared in 1972 in a large-format, untitled picture (pp. 56–57) and became a sort of leitmotif in his production down into the 1980's. Seen on a car coming from the opposite direction, this ornamental motif, as Johns recalled, "had all the qualities that interest me— literalness, repetitiveness, an obsessive quality, order with dumbness, and the possibility of a complete lack of meaning." In the course of the 1970's, it proved to be a flexible instrument, which was capable of further development in various directions. In *Scent* (pp. 58–59)—a title alluding to two eponymous paintings by Pollock and Rauschenberg—Johns expanded the motif into a flat, all-over composition. In *Corpse and Mirror II* (p. 60), the crosshatchings on the right side

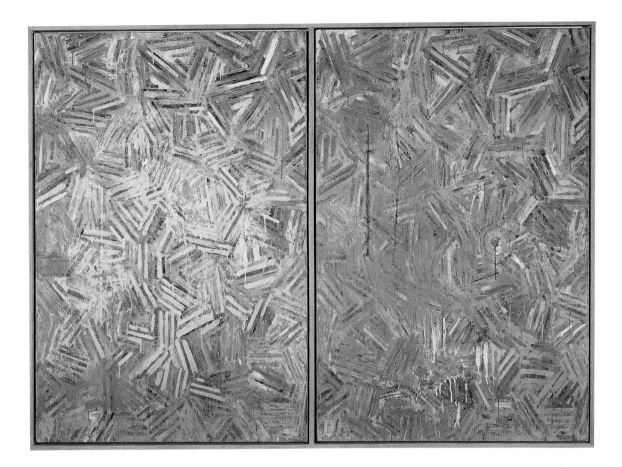

The Dutch Wives, 1975
Encaustic and collage on canvas (two panels),
131.4 x 180.3 cm
Artist's collection

formed a symmetrically reversed correspondence to the left side, while the patterns of the three sections of the left side were arranged without relationship to one another. The title quotes the Surrealist game of "exquisite corpse," in which a first drawing or beginning of a sentence on a sheet of paper is continued by the next player, and so on, without any player having seen the previous contributions. Procedures such as mirrorings, reversals, and rotations of motifs, which repeatedly occur in Johns's paintings, are not least a reflection of his intensive concern with printing techniques, which occupied a considerable scope in his production from the early 1960's onwards. *The Dutch Wives* (p. 61), played in an ironic way on the idea of the surrogate. "A Dutch wife," explained Michael Crichton, "is a board with a hole, used by sailors as a surrogate for a woman." The two parts of *The Dutch Wives* appear identical only on first glance, for the right contains the suggestion of a circular hole, which might allude to it being a "surrogate" for the left side.

A symbolic visual language that links sexuality with death characterized a series of paintings based on crosshatching in which Johns integrated Tantric motifs. Johns found patterns for schematic representations of sexual union such as those seen in *Cicada* (p. 64) and *Tantric Detail* (pp. 62, 63) in a book on Nepalese art by Ajit Mookerjee. The drawings of a cicada at various stages of its development in *Cicada* might be meant to evoke a transformation process, as

Tantric Detail I, 1980
Oil on canvas, 127.3 x 86.7 cm
Artist's collection

Tantric Detail II, 1981
Oil on canvas, 127 x 86.4 cm
Artist's collection

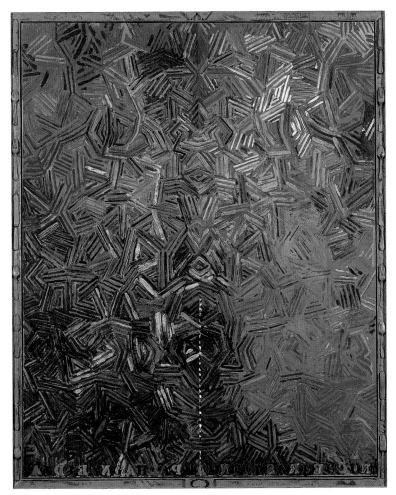

might also the stylized flame, which was derived from a Nepalese depiction of a
cremation. The inscription at the lower picture edge quotes the title of a news-
paper article: "Pope Prays at Auschwitz: 'Only Peace.'" As the article describes
a visit by Pope John Paul II to the Auschwitz concentration camp, this quote
immediately expands the painting's frame of reference into the historical and
political sphere.

The circle of variations on the diagonal hatching motif—taken from everyday
visual culture and possibly "completely lacking in meaning"—was in a sense
closed by *Between the Clock and the Bed* (pp. 66–67). In 1981 an acquaintance
had sent Johns a postcard of the Edvard Munch painting of that title, done in
1940–42. This self-portrait shows the Norwegian artist standing between a
grandfather clock—symbol of a lifetime running down—and a bed, whose
blanket is rendered with crosshatched strokes similar to those Johns employed.
In terms of subject, Munch's painting bore analogies with Johns's compositions
on Tantric motifs; formally, it pointed in the direction of the paraphrasing
quotations in his own idiom to which Johns increasingly devoted himself in
the 1980's.

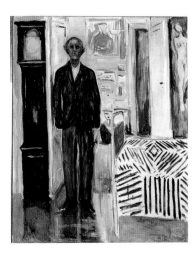

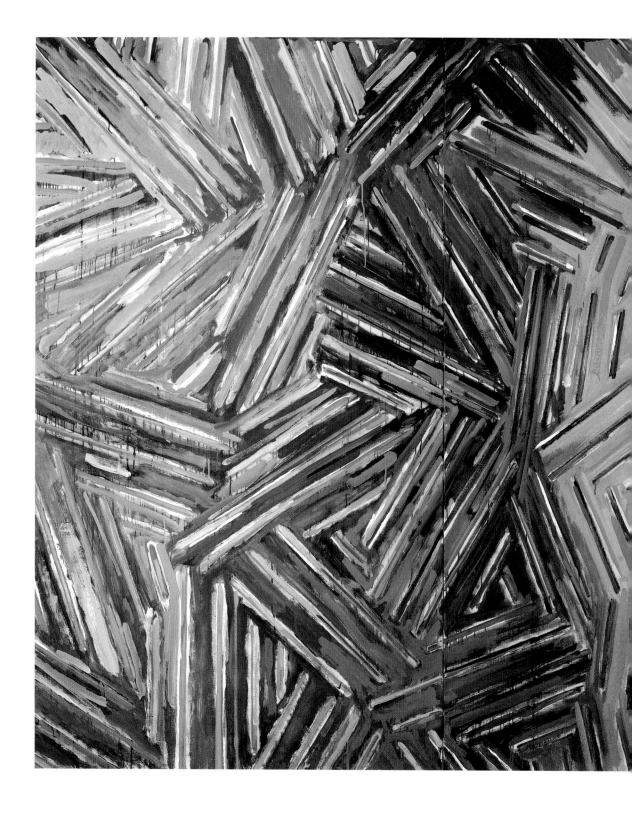

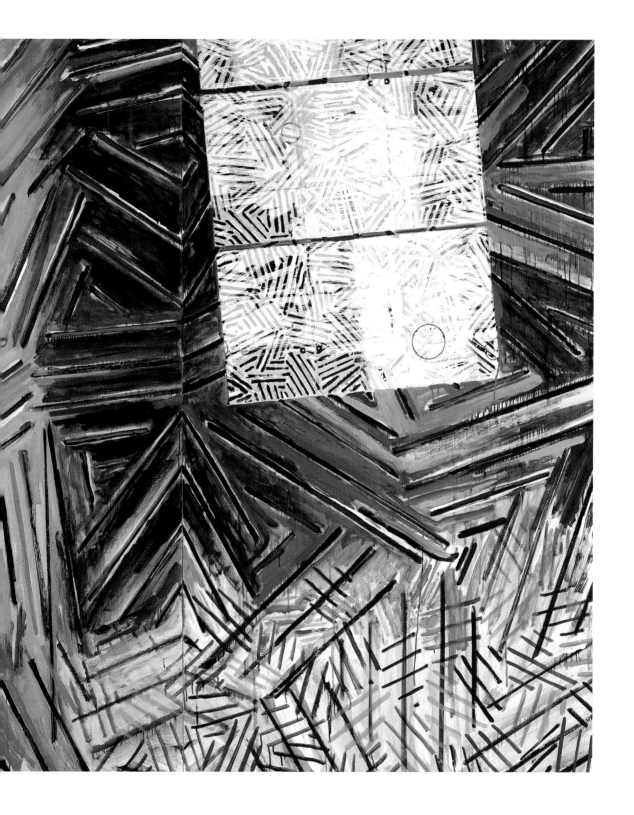

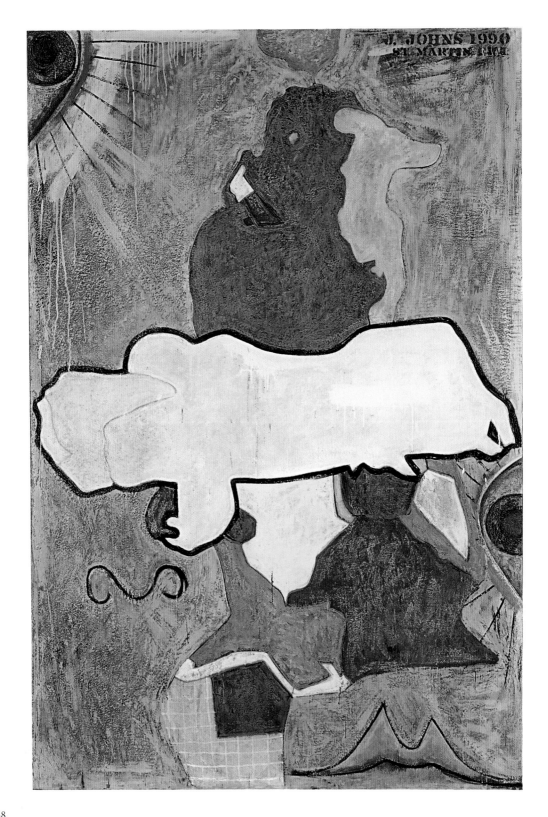

"More than One Person"

Johns's works of the 1980's provide various aesthetically staged views into private spaces such as studios, bathrooms, and floor plans of houses or buildings where the artist once lived. At the same time, they contain verbal and visual quotes that refer to mental situations. "In my early work I tried to hide my personality, my psychological state, my emotions," Johns explained in 1984. "This was partly to do with my feelings about myself and partly to do with my feelings about painting at the time. I sort of stuck to my guns for a while, but eventually it seemed like a losing battle. Finally, one must simply drop the reserve."

Johns's painting *In the Studio* (p. 71) has been compared with Gustave Courbet's monumental canvas *The Studio of the Painter* (*L'Atélier du peintre*, 1855), and described as a "real allegory" of his life as an artist, because it includes various quotes from his oeuvre. In addition, *In the Studio* focuses on the problems of illusionism after a long period of planar abstraction. The integrated objects, such as the cast of an arm and a wooden slat, produce real shadows. In contrast, the trapezoidal area at the lower edge—inspired by a canvas leaning against the wall—and the painted nails with which the two versions of *Between the Clock and the Bed* (pp. 66–67) appear to be affixed to the wall, engender perspective illusion. These elements allude to American trompe-l'oeil painters of the nineteenth century, such as John F. Peto, whom Johns had already previously quoted in the early 1960's in *Cup We All Race 4*. Johns was very much aware of the dubious historical legitimacy of such conventionally illusionistic approaches, as he admitted in a conversation with Ruth Fine and Nan Rosenthal: "Yet I have at times seen no other way to proceed."

Similar to *In the Studio,* the painting surface in *Perilous Night* (p. 70) is treated as an imaginary wall that functions as a support for various visual elements. The whitish paint splatters in the left half of the image are a device that had occurred quite frequently in Johns's paintings from about 1963 onwards. This device alludes to "accidents" in the painting process and simultaneously to the "ejaculatory" projectiles in Duchamp's *The Bride Stripped Bare by her Bachelors, Even (The Large Glass)*, which has been interpreted as a symbol of masturbatory sexuality. The title *Perilous Night* quotes the eponymous 1944 composition by John Cage, the score of which is integrated in the composition as well. Cage's *The Perilous Night* refers to a passage from the saga of King Arthur, "The Perilous Bed," a magnificent bed on which some of the seekers of the Grail were attacked at night

***Untitled**,* 1996
Monotype on paper, 106.7 x 59.7 cm
Artist's collection

ILLUSTRATION PAGE 68:
***Green Angel**,* 1990
Encaustic and sand on canvas, 190.8 x 127.4 cm
Minneapolis, MN, Collection Walker Art
Center. Anonymous gift in honor of Martin
and Mildred Friedman, 1990

by invisible enemies. Cage's composition relates, as he said, to the "loneliness and terror that comes to one when love turns unhappy."

The left half of Johns's *Perilous Night*—which exists in the form of both a painting and a drawing—is occupied by a motif taken from the source he probably quoted most frequently in the 1980's: the *Isenheim Altarpiece* by Matthias Grünewald (c. 1512–16). Johns had first seen the late-Gothic altarpiece in Colmar, commissioned by the Order of St. Anthony in Isenheim, during a journey to Alsace in 1976. St. Anthony was the patron saint of the sick, and the pious brethren believed in the healing effect of viewing the altar. In spring 1980 Johns received the present of a portfolio with 49 photographs of the altarpiece, printed in Munich in 1919, and began to make drawings after details in the photographs. Johns focused on two figures in the paintings who would subsequently play a role in many of his works: a bloated, scrofulous demon from the altar panel representing the Temptation of St. Anthony, and two sleeping soldiers from the depiction of the Resurrection of Christ. In appropriating these motifs, Johns concentrated on their contour lines, "drained of illusionism, reduced to pattern." Tracing and filling out these contours appeared to offer an opportunity to leave the traditional meanings of the famous original behind and see its formal language in fresh terms. "I felt there was some aspect that seemed to be 'underneath' the meaning—you could call it composition—and I wanted to trace this, and get rid of the subject matter, and find out what it was," as Johns explained to Michael Crichton.

Perilous Night, 1982
Encaustic on canvas with objects,
170.2 x 243.8 x 12.7 cm
Washington, DC, National Gallery of Art.
Collection Robert and Jane Meyerhoff

ILLUSTRATION PAGE 71:
In the Studio, 1982
Encaustic and collage on canvas with objects,
182.9 x 121.9 cm
Artist's collection

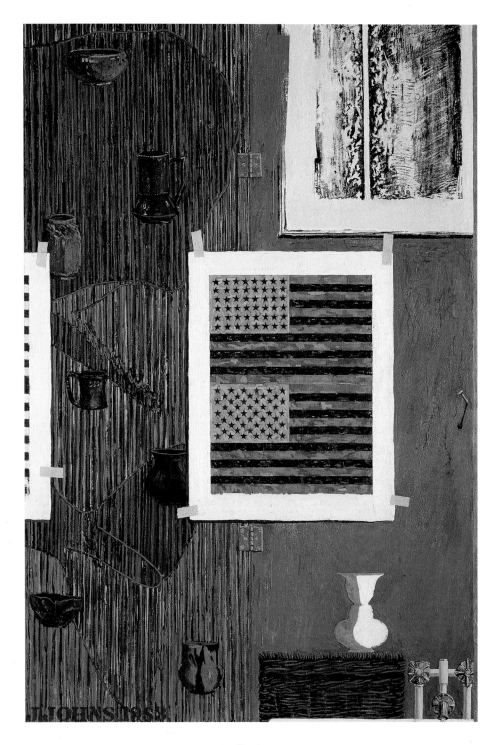

Ventriloquist, 1983
Encaustic on canvas, 190.5 x 127 cm
Houston, TX, The Museum of Fine Arts. Museum purchase with funds
provided by the Agnes Cullen Arnold Endowment Fund

In a certain sense this attempt to "get rid of the subject matter" seemed to be just as much a "losing battle" as Johns's earlier attempt to hide his personality. Ever since the early 1960's, when Leo Steinberg saw the courage of unvarnished autobiography in Johns's art, interpretation after interpretation resorted to biographical information. The widespread assumption that a picture like *Perilous Night* contained encoded biographical references was just as predictable as Johns's refusal to admit any such thing: "It had to do with—what *did* it have to do with? I don't know," he told Barbaralee Diamonstein in 1994. The majority of commentators were hardly in a position to abstract from the traditional significances of the elements in the *Isenheim Altarpiece*, especially as Johns linked these with further quotes that appeared to point in a similar direction. For instance, the figure of the diseased demon appeared in a watercolor that, apart from further quotes and self-quotes, contained an excerpt from *The New York Times* for Valentine's Day 1988 (p. 73 top). "Spread of AIDS Abating, But Deaths Will Still Soar," read one of the headlines. The work was done as a donation to a benefit auction in support of a New York hospital.

Johns's numerous references in the 1980's to prominent works by other artists—besides Grünewald, especially Picasso, Cézanne, Hans Holbein the Younger, and Leonardo da Vinci—triggered a sort of "iconographic truffle hunt" among critics and art historians, as Scott Rothkopf noted. These attempts to identify and interpret his models sometimes prevented a perception of other, more important traits of Johns's imagery. Johns reacted, among other things, by introducing a quote whose source he purposely left in the dark: the figure

Untitled, 1988
Watercolor, ink, and graphite pencil on paper,
79.7 x 120.3 cm
Collection Mr. and Mrs. Irving Mathews

ILLUSTRATION PAGES 74–75:
Racing Thoughts, 1983
Encaustic and collage on canvas, 121.9 x 190.8 cm
New York, Whitney Museum of American Art

Untitled, 1984
Encaustic on canvas, 127 x 190.5 cm
Artist's collection

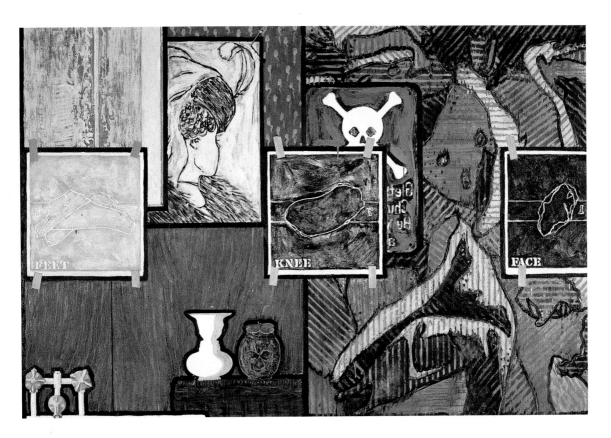

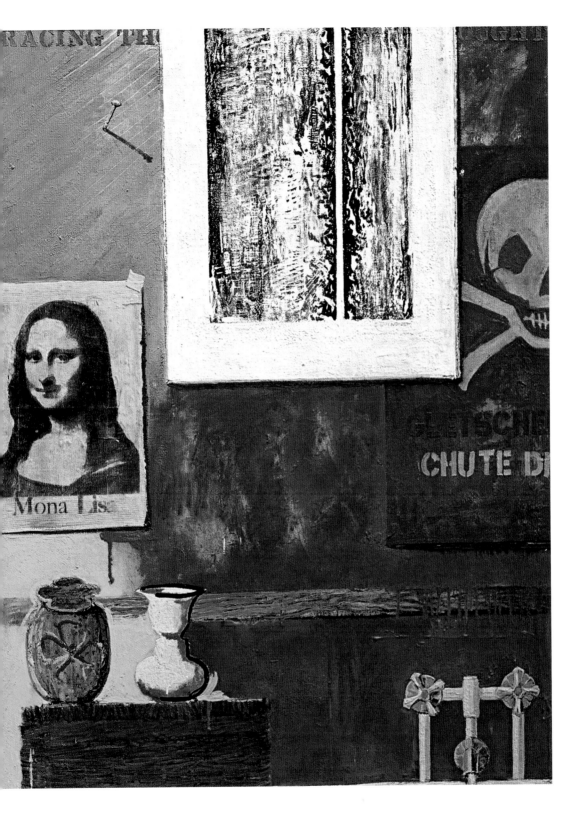

The Seasons, 1989
Ink on plastic, 66 x 147.3 cm
Artist's collection

Summer, 1985
Intaglio on paper, 29.9 x 21 cm
Frontispiece for *Poems* by Wallace Stevens,
Arion Press
Minneapolis, MN, Collection Walker Art Center,
Library

of the *Green Angel* (p. 68), which appeared from 1990 onwards in over 40 paintings, drawings, and prints. "I got tired of people talking about things that I didn't think they could see in my work …" he told Amei Wallach in 1991. "It interested me that people would discuss something that I didn't believe they could see until after they were told to see it." The hunt for clues was made even more difficult by the artist's conscious alienation of certain elements of his *Green Angel*. Although the figure's name leads back to a green-clad angel in a panel of the *Isenheim Altarpiece,* this figure apparently cannot have served as a visual model for Johns's version. The angel playing music in Grünewald's depiction of the Birth of Christ has itself prompted contradictory interpretations. Some art historians, as Joan Rothfuss notes, have viewed it as an allegory of hope, while others have seen it as an image of the fallen angel Lucifer. By introducing *Green Angel*, Johns again drew attention to ambivalences and unanswerable questions of the kind that his work had raised ever since the first *Flag* painting (p. 9).

In addition, a title like *Racing Thoughts* (pp. 74–75) suggests that there may have been no strict connections at all between the elements of his collage-like compositions of the 1980's. Perhaps the only thing shared in common by the motifs and objects in the picture—a portrait of Leo Castelli, a reproduction of the *Mona Lisa*, a print by Barnett Newman, a Swiss avalanche warning sign, a vase, and a ceramic vessel—was the fact that they were all present in Johns's house or studio at the time. The title refers to a mental disturbance the artist experienced back then: "Images, bits of images, and bits of thoughts would run through my head without any connectedness that I could see." Johns described the phenomenon to a child psychiatrist he knew, who provided the medical designation for it. Knowing this term, Johns said, put the whole thing in perspective, and when the painting emerged, this title seemed precisely right.

The bathtub faucet at the lower edge of *Racing Thoughts*, an element that occurred in several works of the period, derives from the bathroom in Johns's former house in Stony Point. It suggests that the picture plane be viewed from a vantage point that Nan Rosenthal called the "bathtub's-eye view." The contour lines in the left half of the picture represent an enlarged detail from a woodcut by Barry Moser, who illustrated Herman Melville's novel *Moby Dick*.

Tracing, 1989
Ink on plastic, 92.1 x 78.7 cm
Collection Anne and Anthony d'Offay

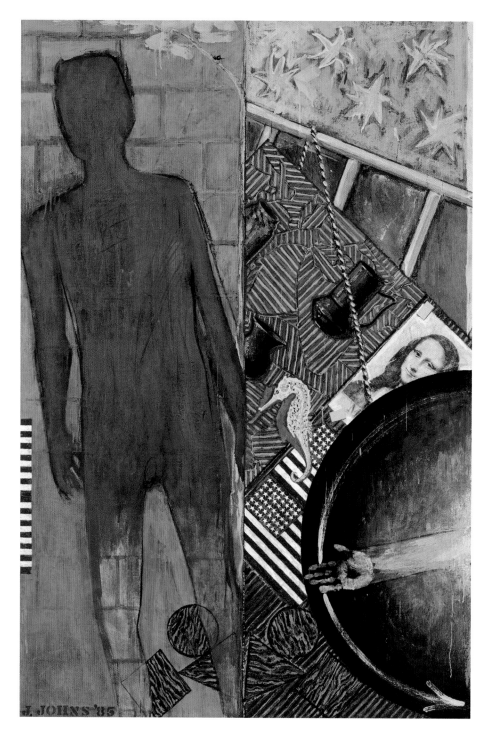

Summer, 1985
Encaustic on canvas, 190.5 x 127 cm
New York, The Museum of Modern Art.
Gift of Philip Johnson

Fall, 1986
Encaustic on canvas, 190.5 x 127 cm
Artist's collection

Winter, 1986
Encaustic on canvas, 190.5 x 127 cm
Private collection

Spring, 1986
Encaustic on canvas, 190.5 x 127 cm
Collection Robert and Jane Meyerhoff

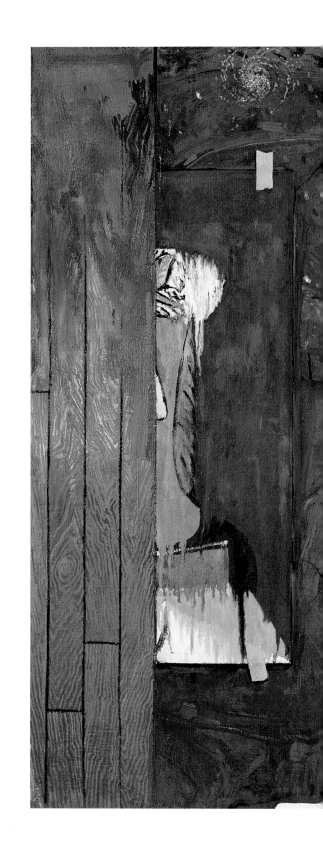

Untitled, 1988
Encaustic on canvas, 122.6 x 153 cm
Collection Joel and Anne Ehrenkranz

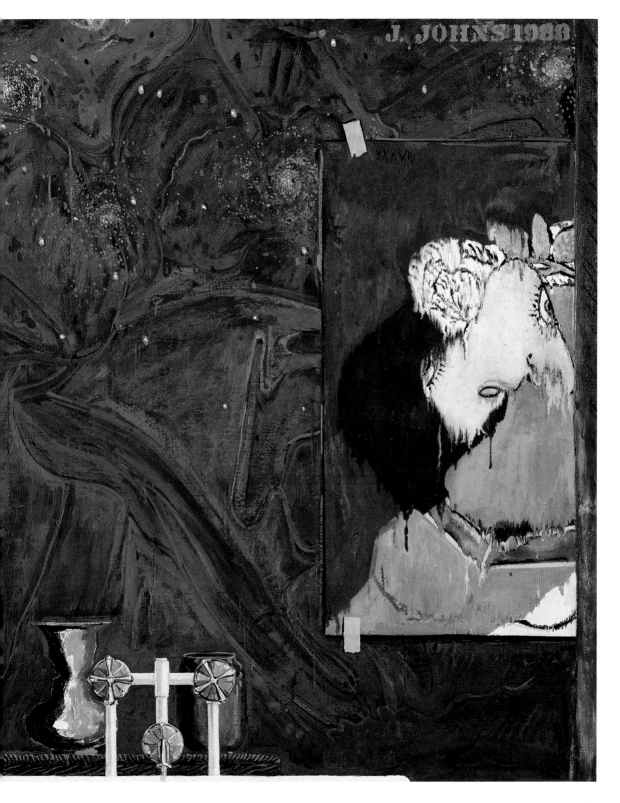

Face with Watch, Universal Limited Art
Editions, 1996
Intaglio on paper, 106.7 x 81 cm
Minneapolis, MN, Collection Walker Art Center.
Gift of the artist, 1998

 Ventriloquist (p. 72) is often linked with a work by Frida Kahlo which Johns saw at the time. *What the Water Gave Me* (*Lo que el agua me ha dado*, 1938), shows the surface of the water in a bathtub on which the artist is observing scenes from her life. Beyond this, the bathtub motif has been linked with the Baptist confession and the ritual of baptism—Johns's grandfather, with whom he lived for five years as a child, was a Baptist.

 In 1983, Johns began to employ a series of motifs from perceptual psychology, which challenged the "business of the eye" to a special degree. These included the Rubin Vase, named for the Danish psychologist Edgar Rubin, which can be perceived either as a vase or as two faces in profile opposite one another. The white vase in *Racing Thoughts* and *Ventriloquist* goes back to a three-dimensional object, produced in 1977 for the 25th jubilee of the coronation of Queen Elizabeth II, that unites the profiles of Elizabeth and Prince Philip. Related motifs are the drawing *My Wife and My Mother-in-Law*, 1915, by W. E. Hill, in which both the

ILLUSTRATION PAGE 84:
Montez Singing, 1989
Encaustic and sand on canvas, 190.5 x 127 cm
Private collection

profile of a young and an elderly woman can be detected, or the optical illusion known as the "rabbit duck," 1899, by Joseph Jastrow, which can be seen alternately as a duck's or rabbit's head. A further example of such optical effects is Johns's depiction of the American flag in complementary colors, as in *Ventriloquist*. When the image is viewed with concentration for several minutes and then the gaze averted, the flag appears on the retina in its true colors, a physiological reaction known as an after-image.

While the optical illusions quoted by Johns point to ambivalent perceptions on a physiological level, paintings such as *Untitled,* 1991 (p. 87) and *Untitled,* 1995 (p. 86) go back to a children's drawing associated with a mental disturbance. This was described by the child psychologist Bruno Bettelheim in a 1952 essay on the case of a girl who had contracted schizophrenia after being separated from her mother. According to Bettelheim, the girl associated herself with both the baby and the mother in the drawing. *The Baby Drinking the Mother's Milk from the Breast* shows stylized breasts and facial features on a square area framed by fingerprints. Johns found a similarly unusual displacement of facial features in Picasso's *Straw Hat with Blue Foliage* (*Le chapeau de paille au feuillage bleu,* 1936). He adapted this form of portrait in works such as *Montez Singing* (p. 84), whose title alludes to his grandmother, Montez Johns. With his reference to Bettelheim's case study and the depiction of his grandmother, Johns moved into a field that can be understood as self-portraiture in the broadest sense of the word. "'I think you can be more than one person,'" Crichton quotes him as saying. " ' I think *I* am more than one person. Unfortunately.' And then he laughs."

In the middle of the 1980's, Johns was asked to illustrate an edition of poems by Wallace Stevens, a distinguished American poet and essayist. "The poem must resist the intelligence / Almost successfully," Stevens had written in 1949, a motto that could just as well be applied to Johns's working method. Johns designed the frontispiece to the book (p. 76) after a painting done a short time before (p. 78). Subsequently he developed a cycle on the four seasons, which are conventionally linked in art with the ages of life (pp. 78–81). In the case of the *Seasons* cycle, too, a search for the sources of these condensed and multilayered compositions leads in various directions. The motif of the ladder and shadow, for instance, has been traced back to Picasso's *Minotaur Moving His House* (*Minotaure à la carriole,* 1936), and *The Shadow* (*L'ombre,* 1953). Beyond this, further possible sources for these and other elements can be named, such as the Jewish Kabala or the Old Testament symbol of Jacob's Ladder.

When, after a comprehensive retrospective of his oeuvre in 1996–97, Johns began a new group of works with apparently "emptied" surfaces, the critics attributed this to at least two reasons: the desire for a reorientation following the look back over an extensive and diverse life's work, and the circumstance that "Jasper Johns's paintings had grown too full," as Scott Rothkopf wrote. The first paintings of the *Catenary* series resemble gray, framed school blackboards. The term "catenary" comes from engineering, and designates the curve of a flexible chain suspended between two fixed points. A key element of the series is threads or strings, painted or actual, running across the picture plane. The *Catenary* series once again referred to Hart Crane's poem *The Bridge*, whose central motif, the Brooklyn Bridge, is one of the earliest and most important suspension bridges in the United States. Yet as regards possible sources, this series too presents an either-or situation. Richard Field was the first to publish a further original from Johns's archive which may have influenced the emer-

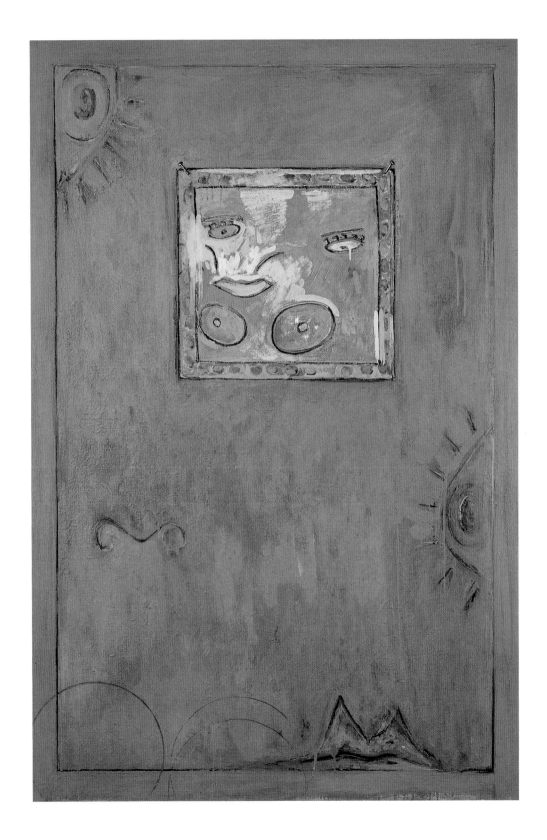

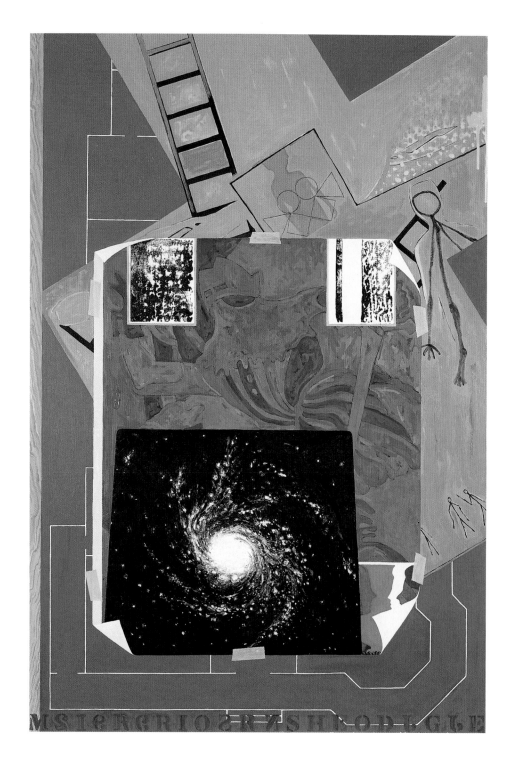

Mirror's Edge, 1992
Oil on canvas, 167.6 x 111.8 cm
Collection Mr. and Mrs. S. I. Newhouse

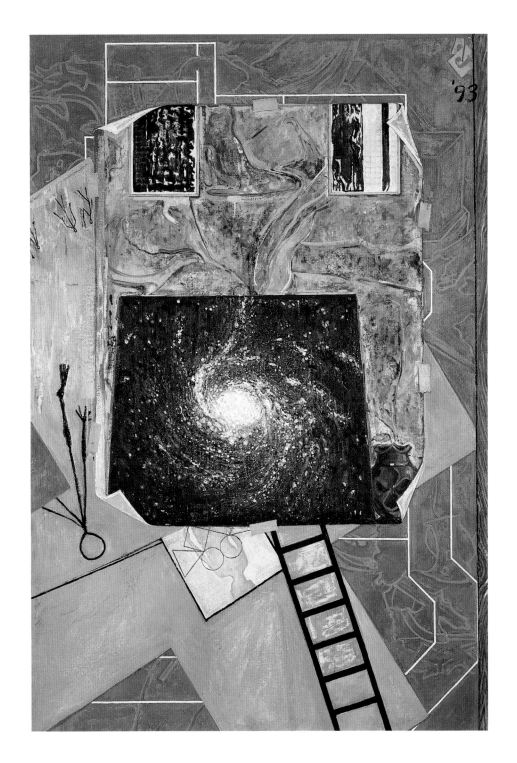

Mirror's Edge 2, 1993
Encaustic on canvas, 167.6 x 111.7 cm
Collection Robert and Jane Meyerhoff

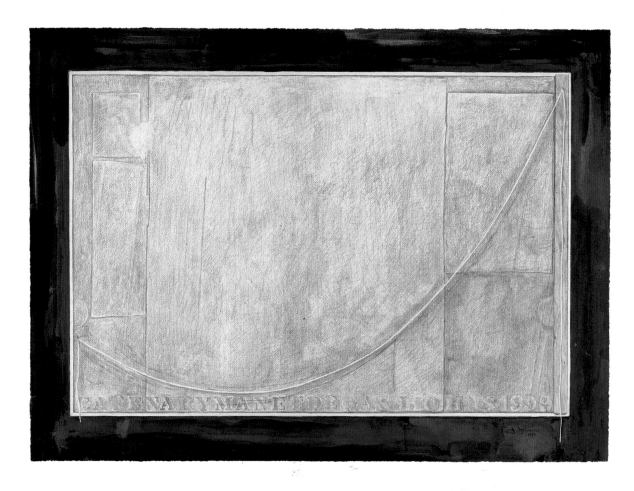

Catenary (Manet-Degas), 1999
Graphite, watercolor, acrylic and ink on paper,
61.9 x 85.4 cm
New York, Whitney Museum of American Art.
Gift of the American Contemporary Art Foun-
dation, Inc., Leonard A. Lauder, President
2002.281

The first paintings of the *Catenary* series, begun
after a large retrospective of his art, were com-
pared with a tabula rasa. The dangling curve of
the threads, painted or actually affixed to the
surface, suggest an aspect of motion and active
intervention on the part of the viewer.

gence of the curve motif: a carefully composed color press photo by John Parkin,
which Johns found in *The New York Times* in 1996. The photo shows two Rwandan
refugees, a seated Hutu woman receiving an infusion, as her mother holds up the
bottle such that the tube describes a suspended curve. The political context of
the photo is no longer visible in Johns's *Catenary* series; rather, the motif of the
dangling string is translated into a universal, existential symbol. Like the *Seasons*,
the *Catenary* series deals with situations of transition—"From going to and fro
in the earth," as Crane quoted from the Book of Job at the beginning of his text.
Johns once explained that many elements of the series were derived from child-
hood memories, such as the family picture and the diamond and dragon patterns.

Catenary builds bridges not only to an individual past but to art history as
well. The lozenge patterns recall Picasso's depictions of harlequins from the
first decade of the twentieth century. In *Catenary (Manet-Degas)* (p. 90), Johns
adopted the compositional structure of a fragmentary version of Edouard Manet's
Execution of Emperor Maximilian (*L'Exécution de l'Empereur Maximilien*, 1867),
which had been reconstructed by Edgar Degas. In view of the *Catenary* series,
Richard Field spoke of "chains of meaning,"—an apt description of the play
with constructs of meaning that characterizes Johns's visual language as a whole.

One work of the series is planned such that viewers can alter the position
of the string or let it dangle freely from one side of the frame. This invitation

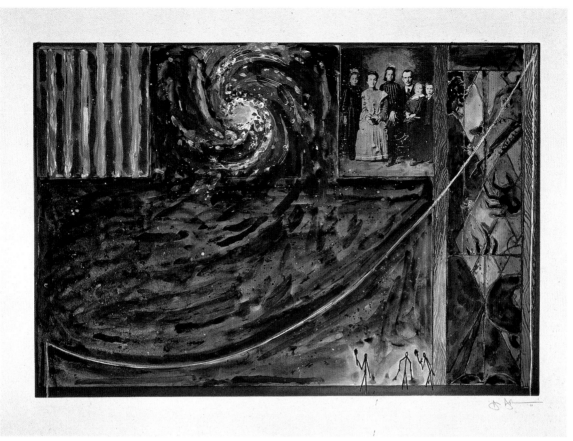

Untitled, 2001
Watercolor and gouache over intaglio on paper,
62.2 x 81.6 cm
Artist's collection

to physical interaction shows a continuity with Johns's early assemblages, such as *Construction with Toy Piano* (p. 18) and *Target with Plaster Casts* (p. 14). The reference to mutability may be the most optimistic facet in Johns's artistic process, which is otherwise marked by deep skepticism. "It's important that one sees the instability of what one is looking at—that it could be changed," he explained to Scott Rothkopf. "I like that you're aware of other possibilities, whether you wish to set them in motion or not." The possibility of change is inherently contained in ambivalence and indistinguishability. It exists as an equal option, as in an optical illusion. In an obituary for Duchamp, Johns noted the artist's "unwillingness to consider any definition as being final"—a description that applies equally well to his own approach to art.

Jasper Johns
Chronology

1930 Jasper Johns is born on 15 May in Augusta, Georgia.

1932–1946 After his parents divorce, he lives with relatives. Begins drawing at age three, and from age five, knows that he wants to become an artist. Graduates from high school while living with his mother and stepfather in Sumter, South Carolina.

1947–1948 Studies art at the University of South Carolina, Columbia.

1948–1949 Goes to New York, where he takes courses at the Parsons School of Design.

1951 Johns is inducted into the army in Columbia, South Carolina. While stationed at Fort Jackson, he founds a cultural center.

1952–1953 During the Korean War, Johns is stationed for six months in Sendai, Japan.

Jasper Johns in the ULAE workshop, West-Islip, New York, 1962
Photo Hans Namuth

ILLUSTRATION PAGE 93:
Jasper Johns in Edisto Beach, 1965
Photo Ugo Mulas

1953 Registers at Hunter College on the G. I. Bill, a scholarship program for veterans. Suffers a breakdown on the first day and decides not to pursue his studies further.

1953–1954 Works at Marboro Books, an art bookshop. Johns is introduced to Robert Rauschenberg by author Suzi Gablik. Destroys the larger part of his earlier works.

1954 Becomes acquainted with the composers Morton Feldman and John Cage, and the dancer and choreographer Merce Cunningham. Helps Rauschenberg produce display window decorations. Begins his first *Flag* painting (p. 9). In December, participates in a group show at Tanager Gallery, with *Construction with Toy Piano* (p. 18).

1955 Paints his first target picture, *Target with Plaster Casts* (p. 14). Johns and Rauschenberg establish the firm Matson Jones—Custom Display. Begins designing stage sets and costumes.

1956 First alphabet painting, *Gray Alphabets* (p. 13). Matson Jones—Custom Display decorates show windows for Tiffany & Co. and Bonwit Teller, where *White Flag* (p. 8) is shown as part of a window display.

1957 First painting with a sequence of numbers, *White Numbers* (p. 12). In March, Johns participates with *Green Target* (p. 10) in the group show "Artists of the New York School: Second Generation," at the Jewish Museum. In May, Johns is included in a group exhibition at the Leo Castelli Gallery. The critic Robert Rosenblum describes his work as "neo-Dada."

1958 First one-man show, at the Leo Castelli Gallery. All but two of the works on view are sold, three to the Museum of Modern Art. *Artnews* magazine reproduces *Target with Four Faces,* 1955, on its cover. First sculptures

in Sculpmetal, *Flashlight I* (p. 34 bottom) and *Lightbulb I*. At the XXIX Venice Biennale, Johns's works are on view in Europe for the first time.

1959 First solo shows in Paris and Milan. Marcel Duchamp and the critic Nicolas Calas visit Johns's studio.

1960 Beginning of involvement with printmaking techniques, and return to motifs from his paintings, such as flags, targets, and numerals. First bronze sculptures (p. 35).

1961 Works with body imprints and the motif of the United States map

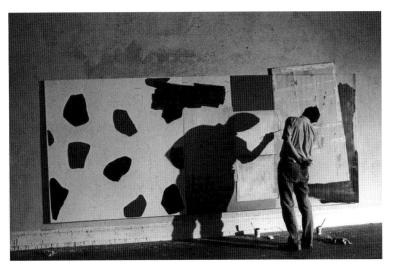

The artist working on *Harlem Light* (pp. 54–55), 1967
Photo Ugo Mulas

ILLUSTRATION PAGE 95:
The artist working on *Numbers,* 1997
Photo Hans Namuth

(pp. 46–47). Buys a house in Edisto Beach, South Carolina. Exhibits at Galerie Rive Droite, Paris. In late summer, participates in the show "Le Nouveau Réalisme à Paris et à New York," at the same gallery.

1962 Galerie Ileana Sonnabend is inaugurated in Paris with a Johns show.

1963 Leo Steinberg publishes the first monograph on Johns. The artist participates in the exhibition "Pop Art USA," at the Oakland Art Museum in California, and becomes a founding director of the Foundation for Contemporary Performance Arts, Inc.

1964 Retrospective of over 170 works at the Jewish Museum, New York, which travels to England and California. Represented with 20 works at the XXXII Venice Biennale, and participates in Documenta III, Kassel.

1966 Johns's house and studio in Edisto Beach are destroyed by fire.

1967 Johns becomes artistic adviser to the Merce Cunningham Dance Company, a position he will hold until 1978. In *Harlem Light* (pp. 54–55), he works for the first time with the flagstone motif.

1968 Writes an obituary on Duchamp for *Artforum.*

1969 Max Kozloff's monograph on Johns is published. Awarded honorary doctorate in Humane Letters by the University of South Carolina.

1970 Honored with the Creative Arts Award Citation for Painting by Brandeis University in New York.

1972 In *Untitled* (pp. 56–57), Johns introduces the motif of crosshatching, which would become the principal motif in his paintings from 1974 to 1982. Receives the Skowhegan Medal for Painting. Acquires a house and studio on the Caribbean island of Saint-Martin in the West Indies.

1973 Elected a member of the National Institute of Arts and Letters, New York. In Paris, meets Samuel Beckett to discuss a potential collaboration. They jointly produce a book, *Foirades/Fizzles,* published in 1976.

1977–1978 Receives the Skowhegan Medal for Graphics. Large retrospective, organized by the Whitney Museum, New York, which travels to Cologne, Paris, London, Tokyo, and San Francisco.

1979–1981 Return to employment of objects such as knives, forks and spoons. Involvement with new, objective forms of depiction such as Tantric motifs (pp. 62, 63).

1980 The Whitney Museum of American Art acquires *Three Flags* (pp. 26–27) for one million U. S. dollars, the highest price yet paid for a work by a living American artist. In the 1980s, Johns's works would repeatedly fetch record prices. Becomes a member of the Académie Royale des Beaux-Arts in Stockholm.

1981 Numerous works based on motifs from Grünewald's *Isenheim Altarpiece* (p. 70).

1982–1984 Johns's painting style changes, as he introduces many new motifs such as optical illusions, visual quotes, and trompe-l'oeil effects (p. 71). Elected member of the American Academy of Arts and Sciences in Boston.

1985–1989 Intensive involvement with Picasso's paintings. Autobiographical allusions become more frequent in John's art.

1986 Johns designs the Medal of Liberty, a bronze cast of a pantographic reduction of the Sculpmetal *Flag,* 1960. On 3 July, the medal is presented by President Ronald Reagan to twelve naturalized U. S. citizens. Johns receives the Wolf Prize for Painting from the Wolf Foundation in Israel.

1988 Awarded the Golden Lion for his exhibition in the American Pavilion at the XLIII Venice Biennale. At a Sotheby's auction, *False Start* (p. 28) attains a record price for the work of a living artist.

1989 Named 38th member of the South Carolina Hall of Fame, and elected member of the American Academy of Arts and Letters.

1990 Receives National Medal of Arts from President George Bush in the White House.

1993 In Tokyo, receives the Praemium Imperiale for Painting, a prize annually awarded by the Japan Art Association, for his life's work.

1994 Awarded Edward MacDowell Medal of the Edward MacDowell Colony, Peterborough, New Hampshire.

1996–97 Retrospective at the Museum of Modern Art, New York, with further venues in Cologne and Tokyo.

1997 Beginning of the *Catenary* series (pp. 90, 91).

1999 Exhibition "Jasper Johns: New Paintings and Works on Paper," San Francisco Museum of Art; travels to Yale University Art Gallery and the Dallas Museum of Art.

2003 Two exhibitions at the Cleveland Museum of Art and Walker Art Center, the latter also shown at other venues in the U. S., in Spain, Scotland and Ireland.

2004 The Leo Castelli Gallery shows "Jasper Johns: Prints from the Low Road Studio," a printmaking studio Johns had opened after moving to Connecticut in 1996.
Jasper Johns lives and works in Connecticut and on Saint-Martin, French West Indies.

Bibliography

Castleman, Riva: *Jasper Johns. A Print Retrospective*. Exh. cat. The Museum of Modern Art, New York, 1986.

Crichton, Michael: *Jasper Johns*, in association with the Whitney Museum of American Art. A revised and expanded edition, New York, 1994.

Francis, Richard: *Jasper Johns*. New York, 1984.

Huber, Carlo (ed.): *Jasper Johns Graphik*. Exh. cat. Kunsthalle Bern, Bern, 1971.

Jasper Johns: *Catenary*. Text by Scott Rothkopf. Exh. cat. Matthew Marks Gallery, New York, 2005.

Kozloff, Max: *Jasper Johns*. New York, 1969.

d'Offay, Anthony (ed.): *Friendships: Cage, Cunningham, Johns*. London, 1989.

Orton, Fred: *Figuring Jasper Johns*. Cambridge, MA and London, 1994.

Rosenthal, Nan and Ruth Fine: *The Drawings of Jasper Johns*. Exh. cat. National Gallery of Art, Washington, DC, New York, 1990.

Rothfuss, Joan: *Past Things and Present: Jasper Johns since 1983*. Exh. cat. Walker Art Center, Minneapolis, 2004.

Shapiro, David: *Jasper Johns. Drawings 1954–1984*. New York, 1984.

Solomon, Alan R. (ed): *Jasper Johns*. Exh. cat. Jewish Museum, New York, 1964.

Steinberg, Leo: *Jasper Johns*. New York, 1963.

Varnedoe, Kirk (ed.): *Jasper Johns. Writings, Sketchbook Notes, Interviews*. Compiled by Christel Hollevoet, The Museum of Modern Art, New York, 1996.

Varnedoe, Kirk (ed.): *Jasper Johns: A Retrospective*. Exh. cat. The Museum of Modern Art, New York, 1996; Museum Ludwig, Cologne, 1997; Museum of Contemporary Art, Tokyo, 1997.

Weitman, Wendy: "Jasper Johns: Ale Cans and Art," *Studies in Modern Art*, no. 1, The Museum of Modern Art, New York, 2001, pp. 38–63.

Photo Credits